Time and the Bible's Number Code

D1599088

TIME

and the
Bible's
Number Code

*An Exciting Confirmation
of God's Time-Line
for Man!*

Bonnie Gaunt

Adventures Unlimited Press
Kempton, Illinois 60946, U.S.A.

Adventures Unlimited Press
P.O. Box 74
Kempton, IL 60946 U.S.A.
auphq@frontiernet.net
www.adventuresunlimitedpress.com

Manufactured in the United States of America

ISBN 0-932813-97-6

Hebrew Gematria is based on the Masoretic Text.
Greek Gematria is based on the Nestle Text

v

Contents

S
80
√8
3
001
. 1

Foreword

Understanding God's time is a worthy pursuit, for it can enable us to orient our place in the time-line of man. Obtaining that understanding is the work of a lifetime. Usually we see only small pieces. But when several of those small pieces begin to fit into place, a larger picture emerges. And when several of those larger pictures begin to fit into place, the beauty and grandeur of the whole scheme of time envelopes us within its sphere. Yes, we are part of the magnificent march of the ages. Finding our place in that grand procession is an exciting adventure.

There are many avenues to explore in the search for an understanding of the time-line of history. Some of them consist of ancient records, astronomical calculations, Biblical history, and the artifacts of man who has gone before. From these a chronology of man can be obtained.

It is the purpose of this book to use additional, lesser known, aids in the confirming of the time-line that has been obtained by the traditional methods. Two of these aids are: 1) Biblical Gematria, and 2) the Golden Proportion. The use of these God-given principles opens a whole new world of excitement and joy, and gives us an insight into the magnificent mind of the Creator.

The old adage: "You can't see the forest for the trees" is true of the study of the time-line of man. It is the pur-

pose of this book to take a look at the forest. Step back, and observe the panorama of its exquisite beauty. It was designed by the hand of the Almighty!

As we stand on the mountain, and see the lovely forest spread out to our view, may you be lifted to new heights of awareness and joy!

Bonnie Gaunt
September, 2001

Hebrew and Greek Gematria

Aleph	א	1	**Alpha**	α	1	
Beth	ב	2	**Beta**	β	2	
Gimel	ג	3	**Gamma**	γ	3	
Daleth	ד	4	**Delta**	δ	4	
He	ה	5	**Epsilon**	ε	5	
Vav	ו	6	**Zeta**	ζ	7	
Zayin	ז	7	**Eta**	η	8	
Cheth	ך ח	8	**Theta**	θ	9	
Teth	ט	9	**Iota**	ι	10	
Yod	י	10	**Kappa**	κ	20	
Kaph	כ	20	**Lambda**	λ	30	
Lamed	ל	30	**Mu**	μ	40	
Mem	ם מ	40	**Nu**	ν	50	
Nun	ן נ	50	**Xi**	ξ	60	
Camek	ס	60	**Omicron**	o	70	
Ayin	ע	70	**Pi**	π	80	
Pe	ף פ	80	**Rho**	ρ	100	
Tsadey	ץ צ	90	**Sigma**	$\sigma\varsigma$	200	
Qoph	ק	100	**Tau**	τ	300	
Resh	ר	200	**Upsilon**	υ	400	
Shin	ש	300	**Phi**	ϕ	500	
Tav	ת	400	**Chi**	χ	600	
			Psi	ψ	700	
			Omega	ω	800	

1
Finding a New Method

Excitement is in the air! With the turn of the millennium, the world has become increasingly aware of the fact that 2,000 years have elapsed since the birth of Jesus. And with this awareness came the awesome realization that Adam's family has been on this earth for about 6,000 years.

Suddenly we find a plethora of books, magazines, and television documentaries all bombarding us with the exciting news that the seventh millennium is upon us, and it is time for the fulfillment of the promised return of Jesus Christ.

If this is true, then it is indeed an exciting time to be living.

How do we know that man has been on this earth for 6,000 years, and how do we know that anything different is expected to happen in the seventh thousand? How do we know that the return of Jesus should be expected at the end of 6,000 years?

Finding the number of years between the birth of Jesus and the current year is simply a matter of historical documentation. But history gets a little fuzzy when we try to count all the way back to Adam. Many (including myself) have spent years compiling detailed year-

by-year histories that reach all the way back to Adam. And, no, I'm not going to bore you with the volumes of elaborate details that fill my files. But neither am I going to expect you to simply take my word for it. There must be a better and more exciting way.

What if we could find whole eras of time that leap over the details, yet give us an accurate overview? And what if we found that these eras of time formed a beautiful pattern? And what if these time patterns fit perfectly with the Number Code (Gematria) of the Bible? Well, not all the "what ifs" in life leave us empty. Many of the "what ifs" have been pursued and the pot of gold has indeed been found at the end of the rainbow. That is what I want to share with you. And if my excitement rubs off along the way, and you become infected with it, just chalk it up to Millennium Fever! So here goes!

Let's start with the whole 6,000 years. Consider it as one era of time. But an era is a group of years that have a common purpose or meaning. What common purpose or meaning do we find characterizes the whole period from King Adam to King Jesus? It is simply a matter of dominion – right of rulership. That's why I called them both "King." Adam was given the right of rulership in the Garden of Eden, at the time of his creation, before he sinned. But at the end of 6,000 years, Jesus becomes the rightful ruler. Thus we are talking about a span of time that reaches all the way from the

creation of Adam to the transfer of the right of rulership. The graphics are simple:

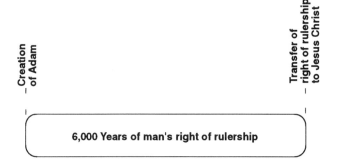

The transferring of the right of rulership does not necessarily mean an abrupt change in government. Adam's heirs do not give up that easily. In Psalm 2 we get a glimpse of the struggle that accompanies this transfer of authority.

> *"The kings of the earth* (Adam's ruling heirs) *set themselves, and the rulers take counsel together, against the Lord, and against his anointed saying, 'Let us break their bands asunder, and cast away their cords from us.' He that sitteth in the heavens shall laugh: the Lord shall have them in derision. Then shall he speak unto them in his wrath, and vex them in his sore displeasure.* **Yet have I set my king upon my holy hill of Zion.**"

From this we know that the transfer of the right of rulership does not immediately usher in a new government. Thus we are not to look for that visible event as the date at which this transfer takes place. It's not that easy. What we must look for is the ending of the 6,000 years that had been allotted to man for rulership. If this date can be found, then we know that the transfer of right of rulership has (past tense) taken place, or will (future tense) take place.

The purpose of this book is to establish that point in time!

In an effort to do this with accuracy we'll look for some new methods of calculation. If these new methods are in perfect sync with the year-by-year detailed chronology, then it can give us added confidence in the accuracy of the calculation.

I invite you to share this journey with me.

2

Why 6,000 Years?

*"And God said: 'Let us make man in our image, after our likeness: and let them have dominion over the fish of the sea, and over the fowl of the air, and over the cattle, and **over all the earth**...'"* (Genesis 1:26)

Not one word is said here regarding the length of time of this God-given right of rulership. So why do we speak of it as extending for 6,000 years? Adam was created on the sixth creation "day." Time, as we know it, had not even begun to count.

Adam was created in perfection, and created to live for an eternity. The years of the counting of his life did not begin until he sinned. It was, in reality, the counting of the years of his dying. But at the time dominion was given to him, his years had not yet begun to count. Thus there was no mention of the counting of time in the conferring upon him the right of rulership of the earth and all that is in it. We must look elsewhere for clues.

Aside from the canonical scriptures, we have many statements of the ancients which reveal an understanding of a 6,000-year period of man's dominion, followed by a 1,000-year rulership of the Messiah. It was a belief

commonly held by the Rabbis of ancient Israel.

It was also the common belief of the early church fathers of the Christian era. Barnabas, the traveling companion of the Apostle Paul wrote concerning this 6,000-year time span (c. A.D. 100); Justin Martyr and Irenaeus also wrote about it (c.A.D. 150); Methodius, Bishop of Tyre (c. A.D. 300); and Lactantius (c. A.D. 325), who was the tutor of Constantine's son, wrote, "Let the philosophers know that the six thousandth year is not yet completed; and when this number is completed, the consummation must take place."

About a century later, Bishop Latimer wrote, in A.D. 1552: "The world was ordained to endure, as all learned men affirm, 6,000 years. Now of that number, there be passed 5,552 years, so that there is no more left but 448 years" (which would be completed in 2000).

A view frequently expressed in the Talmud is that the world as we know it would last only 6,000 years, followed by the work of Messiah.

In a commentary on the Talmud, Rabbi Ketina said:

> The world endures six thousand years and one thousand it shall be laid waste (that is, the enemies of God shall be destroyed), whereof it is said, 'The Lord alone shall be exalted in that day.' As out of seven years every seventh is a year of remission, so out of the seven thousand years of the world,

the seventh millennium shall be the millennial years of remission, that God alone may be exalted in that day.

These are just a few. Where did they get the idea?

Probably from the Torah. God had made it very plain to Moses that just as the creation of the earth and man covered a period of 6 "days," followed by a "day" of rest, so man was to fulfill 6 days of work, followed by a day of rest. The creation week set the pattern.

> *"Verily my sabbaths ye shall keep: for it is a sign between me and you throughout your generations; that ye may know that I am the Lord that doth sanctify you. Ye shall keep the sabbath therefore; for it is holy unto you: every one that defileth it shall surely be put to death: for whosoever doeth any work therein, that soul shall be cut off from among his people. Six days may work be done; but in the seventh is a sabbath of rest, holy to the Lord: whosoever doeth any work in the sabbath day, he shall surely be put to death. Wherefore the children of Israel shall keep the sabbath, to observe the sabbath throughout their generations, for a perpetual covenant. **It is a sign between me and the children of Israel for ever: for in six***

The Creation Week Sets The Pattern for God's Time Cycles

A Week of Days

1st Day (7,000)	2nd Day (14,000)	3rd Day (21,000)	4th Day (28,000)	5th Day (35,000)	6th Day (42,000)	7th Day (49,000)	Followed by the 50th, which is God's Great Jubilee. This Great Jubilee is also the 8th Day of the Creation Week. It is the beginning of eternity.
						Sabbath	

1st Day	2nd Day	3rd Day	4th Day	5th Day	6th Day	7th Day	Followed by the 8th day, which is also the first day of the next cycle.
						Sabbath	

A Week of Weeks

1st Week (7)	2nd Week (14)	3rd Week (21)	4th Week (28)	5th Week (35)	6th Week (42)	7th Week (49)	Followed by the 50th day, which was the day of Pentecost.
						Sabbath	

A Week of Months

1st Month	2nd Month	3rd Month	4th Month	5th Month	6th Month	7th Month	This ends the seven months of the feast calendar, thus the following day represents that which follows completion.
						Sabbath	

A Week of Years

1st Week (7 yrs.)	2nd Week (14 yrs.)	3rd Week (21 yrs.)	4th Week (28 yrs.)	5th Week (35 yrs.)	6th Week (42 yrs.)	7th Week (49 yrs.)	This ends the Sabbath Year cycle, thus the following day is the beginning of the 8th, or the first day of the next Sabbath Year cycle.
						Sabbath	

A Week of Weeks of Years

1st Week (7)	2nd Week (14)	3rd Week (21)	4th Week (28)	5th Week (35)	6th Week (42)	7th Week (49)	This ends the seven Sabbath Year cycles, thus the following day begins the Jubilee, or 50th year, which is the first year of the next Sabbath cycle.
						Sabbath	

A Week of Millennia (Man's Week)

1st M (1,000)	2nd M (2,000)	3rd M (3,000)	4th M (4,000)	5th M (5,000)	6th M (6,000)	7th M (7,000)	This ends the 7,000 years of man's "day," thus the following day begins the great 8th day, which is eternity. It begins God's Great Jubilee.
						Sabbath	

days the Lord made heaven and earth, and on the seventh day he rested, and was refreshed." (Exodus 31:13-17)

The chart on the opposite page reveals the patterns in God's time cycles. The pattern was set with the creation week. Whether we consider each of the creation "days" as a 24-hour day, or as a long epoch of time, we are still confronted with the pattern of 6 + 1 followed by an 8th It appears to be God's pattern of counting time.

Perhaps it is no coincidence that Peter's statement: *"One day is with the Lord as a thousand years, and a thousand years as one day,"* should suggest that man's history would be counted in thousands. The Hebrew word "six," as used in Exodus 31:15 is שֵׁשׁ, and the number values of its letters adds to 1000. Six times one thousand produces six thousand years.

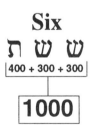

Six

ש ש ת

400 + 300 + 300

1000

Man's week, consists of six days, each one thousand years in length, followed by the seventh, which is a Sabbath of rest – earth's great Millennium.

In the number symbology of the Bible, the number six has reference to the earth and man. Some have suggested that 6 represents sin, but that meaning is only by association with the fact that man has sinned. Basically it represents man. The fact that man has sinned does not change the original meaning of the number. The number also represents man in perfection.

Six is the first perfect number – and it is the only number whose divisors both add and multiply to six.

$$1 + 2 + 3 = 6$$
$$1 \times 2 \times 3 = 6$$

Six circles of the same size can be placed around a seventh of the same size, with each of the six touching the seventh and its companions on both sides. To the ancients, this arrangement represented the week. Its six days of activity focused around the seventh, a Sabbath day of rest. This principle of six days of activity around one day of rest can be shown in the function of a compass. Its tracer draws a circle, while its central point rests.

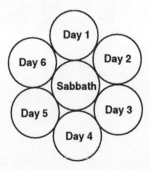

Six is a number that pertains to man and his creation, as well as his environment in which he was created. It is a number that also pertains to his Creator. That it should define the length of time that man was given dominion over his earthly environment seems to be a natural extension of the meanings of this number.

In Isaiah 42:5 we find the phrase, *"Jehovah God that created the heavens."* If we add together the number values for each of its Hebrew letters, the total will be 666. The triplet of sixes is used because it raises the concept of 6 to its highest order.

This same concept can be found in Jeremiah 10:12 which says, *"He hath made the earth."* By adding the number values of each Hebrew letter we again obtain the number 666.

Even the creation of the "lights" in the heavens, which are to shed light upon the earth, respond to this triplet of sixes. *"Let there by lights,"* is found in Genesis 1:14, and its number values again add to 666.

The Greeks had a name for the material order of the universe. They called it *Cosmos, κοσμος.* This word is often used in the New Testament with reference to our planet earth and the society of man upon it. In the King James Version it is translated by the word *"world."* If we add the number values of its 6 letters, we obtain a total of 600.

Our mile unit measures the cosmic intervals in terms

of the number 6. This becomes apparent when consider-
ing the earth and its moon, and the sun which gives us
light.

Diameter of the sun.864,000 miles

\qquad (6+6) x (6+6) x 6000

Diameter of the moon. 2,160 miles

\qquad 6 x 6 x 60

Diameter of the earth.7,920 miles

\qquad (6+6) x 660

Speed of earth around the sun . . . 66,6000 m.p.h.

The Prophet Isaiah, in describing God's blessings
upon Israel, said that they would be a blessing *"in the
midst of the earth."* (Isaiah 19:24) Its number values add
to 600.

On page 9 was shown the Hebrew spelling for the
word "six" which adds to 1000. There are principally
three ways of spelling "six" in the Old Testament. The
basic word is simply שש, which adds to 600. In the
ancient science of Gematria (the number values of the
letters of the alphabet), zeros could be dropped because
they are only place holders and do not change the mean-
ing of the word. Also, the number values of words could
be either added or multiplied. Thus, if we were to multi-
ply ששת x שש the product could be written as 6000.

שׁשׁת = 1000
שׁשׁ = 600

1000 x 6 = 6000

The function of six surrounding a seventh, as was illustrated by the circles on page 10 is a fundamental principle in the structure of creation. It happens naturally in nature. Watch the froth of soap bubbles as it floats on a pan of water, and it will move itself into a multiple pattern of six surrounding the seventh. This is because natural law always seeks the most efficient use of space and energy. One of the most striking examples of this sixness in nature is the formation of the snowflake.

The formation of snowflakes is caused when the temperature of the water molecules drops. This causes the electric charges within each molecule to attract other molecules, then move itself into the most efficient close-packed arrangement. Six water molecules then combine, to form the core of each snowflake. The result is a beautiful six-sided pattern that is infinite in its variety.

Henry David Thoreau mused upon this six-sided wonder that filled the winter air with its beauty. In 1856 he wrote in his journal:

> The same law that shapes the earth-star shapes the
> snow-star. As surely as the petals of a flower are

fixed, each of these countless snow-stars comes whirling to earth, pronouncing thus, with emphasis, the number six. Order, κοσμος... And they all sing, melting as they sing of the mysteries of the number six, – six, six, six. He takes up the waters of the sea in His hand, leaving the salt; He disperses it in the mist through the skies; He recollects and sprinkles it like grain in six-rayed snowy stars over the earth, there to lie till He dissolves its bonds again.

Water is a combination of Hydrogen and Oxygen. These two elements bear remarkable numbers. Hydrogen has an atomic number of 1 and an atomic weight of 1.008. These two numbers, in the Gematria of the Bible represent the Beginning and the New Beginning. Oxygen carries an atomic number of 8 and an atomic weight of 16. The combination of these two elements produces the life-sustaining substance called water. The three numbers involved in these two elements are 1, 6 and 8. Combine the numbers any way we want, or use them individually, and we will always have the concept of creation, life and growth.

The number 1 represents the Creator Himself. He is the Beginning and the Beginner. The number 6 represents the cosmos and God's special creation – man – that He placed in it. The number 8 represents a New Beginning – specifically the New Beginning through the

redemptive blood of Jesus Christ.

Combine these three numbers and we have the speed of light – 186,000 miles per second. The first order of Creation was light. The number 186 has to do with the fact that God is *"from everlasting to everlasting"* as is stated in Psalm 90. The Hebrew word used here, מעולם, has a number value of 186.

Combine them again and we have the Golden Proportion – 1:1.618 – (or, as can also be stated, .618) The Golden Proportion is the divine principle of growth.

Combine them again and we have the basic concept of creation – to give birth. The Greek word τεξεται, meaning "to give birth" has a number value of 681. The Greek word αρτιος, meaning "that which is perfect, or complete," has a number value of 681. The Greek word ατομος, meaning that which is indivisible, or which cannot be cut in two, has a number value of 681. It is the word from which we derive our English word "atom."

Combine them again and we get the number 861. It is a number that carries the meaning of "beginning," as well as that of "everlasting." The Greek word αιων is used in the New Testament and is sometimes translated "world" and sometimes translated "eternity." It has a number value of 861. The Hebrew festival day called Rosh Hashanah, ראש השנה, has a number value of 861. It is their New Year's Day, marking the first day of their civil year. The Hebrew word שפרדרא means the

beginning of a new day. Its number value is 861.

Combine them again and we get 816. It is the number that describes the divine dominion of God over all His creation. It is used in Psalm 103:22 by the Hebrew word ממשלתו, which has a number value of 816. In the New Testament we are given the description of the creation *"In the beginning,"* which was performed by the Word of God (John 1:1). The Greek words used here are *και Θεος ην ο λογος*, meaning *"and God was the Word."* It has a number value of 816.

Combine the numbers 1, 6 and 8 again, and we get the number value of Christ, *Χριστου* – its number equivalents add to 1680.

It becomes obvious. They are not random numbers. They are numbers with a purpose and a meaning. And they all have to do with the Creator and the creation of the world and of man.

Thus it follows in a very logical manner that the dominion given to man would correspond to these basic numbers. The number 1 representing the Beginning; the number 6 representing the cosmos and man, and the number 8 representing the New Beginning through the redemptive blood of Jesus Christ. Thus six "days" from man's creation would bring him through six thousand years and to the beginning of a seventh, a Sabbath of rest. This would be followed by an eighth – the complete restoration of all that Adam lost which is made

possible by the innocent blood of Jesus Christ, which was offered as a payment for sin in the place of the guilty blood of Adam. That payment for the sin of Adam provides mankind with a New Beginning. I like to think of it as God's Grand Octave.

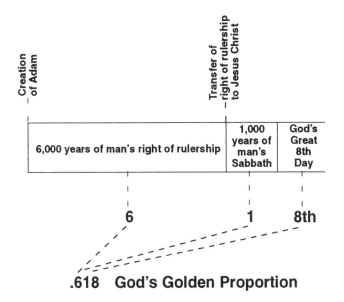

.618 God's Golden Proportion

Thus it becomes apparent that God's Grand Octave is described in terms of His Golden Proportion. This demonstration of God's sacred numbers is stretched across seven thousand years of man's history, bringing us to the Great Eighth Day, in which there is no more counting of time because it is eternity.

No more counting of time? How can that be? Perhaps I should say "time as we know it."

A manuscript known as The Secrets of Enoch, of unknown origin, but translated into the Greek language around the beginning of the Christian era, is quite clear as to the author's concept of the octave of time. This document was known to the early church fathers, and its influence can be seen in their work. It has, in modern times, been translated into English. Chapter 33 begins with this revealing statement, written as if God were doing the speaking:

> And I blessed the seventh day, which is the Sabbath, on which I rested from all my works. And I appointed the eighth day also, that the eighth day should be the first-created after my work, and that the first seven revolve in the form of the seventh thousand, and that at the beginning of the eighth thousand there should be a **time of not-counting, endless** I am self-eternal, not made with hands, and without change. (Emphasis mine)

By definition, this ancient author is saying that 7,000 years became the 7th of the creative six (making a week), and thus making the 8th day of God's great work week to be the beginning of the next cycle, which is eternity. Notice how he defined the 8th day: "a time of not-counting, endless." He is talking about a future event when there will no longer be the counting of time as we know it.

In Genesis 5:3 we have the beginning of the counting of time. It says *"And Adam lived an hundred and thirty years, and begat a son in his own likeness, after his image; and called his name Seth."*

The two verses previous to this gives a brief summary of the "day" in which Adam was created. It reads:

"In the day that God created man, in the likeness of God made he him; male and female created he them; and blessed them, and called their name Adam, in the day when they were created."

The *"day when they were created"* was the sixth day of the creation week. There was apparently a brief span of what we would call "time" between the creation of Adam and the event when he disobeyed God and was driven out of the Garden. During that space, prior to his sin, he lived in perfection. Thus verse 3 begins with the event of his sin, and starts the count of his years – but they were the years of his dying. Nine hundred and thirty years later the dying process was completed for Adam.

The point at which the 7,000 years of man's dying began would have been when the first man began the dying process. Thus when Adam disobeyed God, and was cast out of the Garden of Eden, is the juncture between the 6th creation day and the 7th, which was

God's Sabbath of rest. Prior to the 7th there was not the counting of man's dying – it could be called "eternity," – and following the full counting of the 7,000 years will begin the time when all that Adam lost will be restored to man. Death will be abolished, and man will again be in "eternity."

The Apostle John was given a vision of that future day. He described it in these beautiful words:

> *"And I heard a great voice out of heaven saying, Behold, the tabernacle* (dwelling place) *of God is with men, and he will dwell with them, and they shall be his people, and God himself shall be with them, and be their God. And God shall wipe away all tears from their eyes; and there shall be no more death, neither sorrow, nor crying, neither shall there be any more pain: for the former things are passed away. And he that sat upon the throne said, Behold, I make all things new."*

This is God's great 8th day. This is eternity.

3

The Exact Price of Redemption

How can we know the length of the space between Adam's creation and Adam's sin? Many have speculated. But perhaps we have a clue in the redemptive process.

And, if man's days of counting began with the sin of Adam, why should we be concerned about the length of time between his creation and his sin? It appears to be a legitimate question. For my purposes here, the reason for trying to determine this space betwen his creation and his sin is an attempt to find the beginning and the ending of the right of rulership that was given to Adam. That right of rulership was given to him at the time of his creation, while he was still in the Garden of perfection that God had provided for him. Thus we do not begin counting the 6,000 years of his right of rulership with his sin, but rather with his creation.

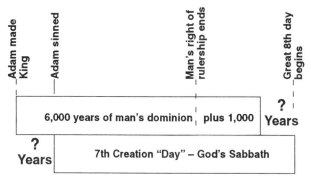

The title of this chapter – "The Exact Price of Redemption" – is precisely the clue to determining this unknown space.

Adam was given a law. He was told: *"Of the tree of the knowledge of good and evil, thou shalt not eat of it: for in the day that thou eatest thereof thou shalt surely die."*

We know the story. Adam did indeed eat of the fruit of the tree, and he did indeed die within that thousand-year "day" – for he lived, after he sinned, for a period of 930 years. Just 70 years short of a full "day."

At the end of his 930 years the death process, which had begun with his sin, was complete. The years of his dying numbered 930.

At the time of his sin, he lost his perfection of man-hood, and he forfeited his life. He was pronounced guilty, and given the sentence of death. Thus this death sentence passed on to all of his posterity.

But there's hope!

In the exact fulfillment of God's perfect time sched-ule, Jesus came to earth to pay the price for Adam's sin. When Jesus hung upon the cross, and His blood spilled upon the ground, He was shedding His innocent blood in payment for the guilty blood of Adam.

The Apostle Paul explained clearly this transaction between Adam and Jesus in the 15th chapter of I Corinthians:

"For since by man (Adam) *came death, by man* (Jesus) *came also the resurrection of the dead. For as in Adam all die, even so in Christ shall all be made alive....And so it is written, The first man, Adam, was made a living soul; the last Adam was made a quickening* (lifegiving) *spirit."*

The first Adam brought death to his human family. The second Adam redeemed Adam and his family. He paid the exact price.

In paying that exact price, it was legally necessary that He be the exact equivalent of Adam. This entitled Him to be called the Second Adam. Therefore if we could find the number of years between the birth of Jesus and the time when He shed His innocent blood for the guilty blood of Adam, then we might have a clue to the space between the creation of Adam and his sin.

In several of my previous books I have addressed this subject in-depth. Thus I will not repeat it here. However, for the benefit of those who still desire to pursue this subject, I refer you to Appendix I in which is shown the historical and astronomical evidence for the dates of the birth and the death of Jesus. This evidence points to His birth as being September 29, 2 B.C., and His death as being April 3, A.D. 33 (both of these dates are according to the Julian Calendar).

The difference between these two dates is 33½ years. Thus at the point in His life when He shed His innocent blood for the guilty blood of Adam was when He was 33½ years old. If He were the exact substitute for Adam, then it suggests that Adam must have sinned after having lived in perfection for 33½ years.

Long before coming to this realization, I had spent many years engaged in an in-depth study of the chronology of man, searching out the year-by-year details of history, from sources Biblical as well as the ancient writings that are not considered canonical. Also much help was obtained from the ancient cuneiform inscriptions which have been translated into English and are available in good libraries. An English translation of the Babylonian Chronicle was also available to my research, as well as astronomical tables. These astronomical tables were compared with the Assyrian Eponym Canon which lists the solar and lunar eclipses which occurred during the reigns of their kings and governors; and also compared with solar and lunar events recorded in the Old Testament. With all of these cross references and intertwined histories of events, the resulting time-line that I obtained flowed from the birth of Jesus, in the autumn of 2 B.C. all the way back to the time when the years of Adam began to count. The figure that I obtained for this event was 3968 B.C. My first reaction to this date was disappointment. It appeared to be between 33 and 34

years short. Where had I gone wrong?

It was then, after much consideration, that I realized I had counted back to the time when Adam sinned, and not back to the date of his creation.

Some of the ancient non-canonical books had suggested that there had been 3,000 years between Adam and King David, and there would be another 3,000 years from King David to King Messiah, making a total of 6,000 years. It was a tradition of the Rabbis of ancient Israel. The idea of 3,000 years between King David and King Messiah fit perfectly into the time-line that I had obtained; but counting back from King David to Adam had left me short by something between 33 and 34 years.

It was not until studying the event of King David's reign that reality became apparent. David was anointed king over all Israel (both Judah and Israel) in the year 1002 B.C. His reign over all Israel was $33^1/_2$ years. We are talking about kingship – the kingship of Adam, the kingship of David, and the kingship of the great antitypical David, King Jesus. There were to be 3,000 years between each of these events. Thus the ancient writers were speaking of the length of time between King Adam and King David. Adam was made a king at the time of his creation in the Garden of Eden. It then became apparent that there must have been $33^1/_2$ years between Adam's creation and the day that he sinned.

King David reigned for $33^1/_2$ years over all Israel.

David was a prototype of King Jesus. David's whole period of reign was occupied with conquering his enemies. Thus it seems fitting that when King Jesus becomes earth's rightful ruler, at the end of man's 6,000 years of dominion, He will possibly use a period of 33^1/$_2$ years in the conquering of the existing earthly governments at the beginning of His reign.

With this analogy, it becomes possible to put dates on our basic time-line, because we have the interim dates of the reign and death of David, and the birth and death of Jesus, which are established dates in the history of man. And in the process, it did not go unnoticed that there were precisely 1,000 years between the year when David was anointed king over all Israel and the year of the birth of Jesus. And likewise there were precisely 1,000 years between the year of David's death and the year of Jesus' death. We appear to be dealing with thousand-year periods of time.

Each span represents 1,000 years

King Adam — Adam sinned — David made king — David died — Jesus born — Jesus died and paid for Adam's sin

It becomes clear that from the creation of Adam to the birth of Jesus is 4,000 years; and from the sin of Adam to the date when Jesus died to pay the price for Adam's sin is also 4,000 years. These two 4,000-year periods are offset by 33$\frac{1}{2}$ years.

Similarly there is another set of 4,000-year periods, offset by 33$\frac{1}{2}$ years, from the time when David became king over all Israel until the end of the Millennium and the time of the *"Little Season"* when Satan will be allowed to prove those who are not on God's side.

Each span represents 1,000 years

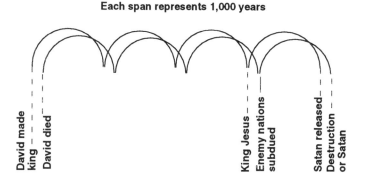

David made king — David died

King Jesus — Enemy nations subdued

Satan released — Destruction or Satan

The first graphic depicted 4,000 years from the entrance of sin, to the payment of the price of redemption. This second graphic depicts 4,000 years from God's typical kingdom to the fulfillment of the promised Kingdom of God. The number 4 in the Bible appears to have reference to a time of trial and judgment. It often comes

in the form of 40. Remember, we can add or drop zeros without changing the meaning. The 40-year period of judgment of Israel during their wilderness journey is an example of the use of this number.

The number 10 is symbolic of man's responsibility to God. Thus man's responsibility to God was displayed in the judgment of sin at its entrance, giving him the need of a Redeemer, and bringing him to the payment of the price of redemption. A period of 10 x 400 years equals 4,000 years. And another period of 10 x 400 years during which man's responsibility to God is brought to judgment, ends with man fully restored to all that Adam had lost through his disobedience.

Previously it was mentioned that when a number is used as a triplet, it raises it to its highest meaning. This same principle applies to the number 10, man's responsibility to God. Multiply three tens (10 x 10 x 10) and we obtain 1,000. This number represents full responsibility to God. We have 7 full thousand-year periods between the time when sin entered, to the time when sin and its results will be fully eradicated. Seven represents completion and perfection.

There was never a man who completed 1,000 years. Methuselah lived the longest, and he died at age 969. Man has never completed his full responsibility to God.

In the Hebrew alphabet, each letter not only represents a number, but it also represents a thing. The alpha-

bet was a series of pictures with meaning. The final letter of the alphabet was *tau*. Today, in square Hebrew it looks like this – ת. However in ancient Hebrew it looked more like our letter T. And it indeed takes the same phonetics as our letter T. It represented a Cross, or Ownership, Finality, and Eternity. These were the meanings of the letter *tau*. It has a number equivalent of 400.

Thus the years between the entrance of sin to the payment of the price of redemption – a period of 10 x 10 x 10 (responsibility to God) x 4 (trial and judgment) – bring us to the day when Jesus hung on the cross and cried *"It is finished."* That cross, represented by the letter *tau,* brought the promise of Ownership, Finality, and Eternity. The years between God's typical kingdom and the completion of His Millennial Kingdom, again a period of 10 x 10 x 10 x 4, will bring us to the day when sin is completely eradicated, and man will come into possession of Ownership, Finality, and Eternity. Then will be brought to fulfillment the promise *"Come, ye blessed of my Father, inherit the kingdom prepared for you from the foundation of the world."* (Matthew 25:34) (Some interpret this as a heavenly promise to the Church, but read it again in its context – it is referring to man's inheritance when he comes into ownership of all that Adam had lost.)

The exact price of redemption was not just the blood that was spilled on the ground – it was the righteous blood

of an innocent, perfect man, who had lived on this earth for a period of 33$\frac{1}{2}$ years. He was the exact equivalent of Adam, who, after living in perfection for 33$\frac{1}{2}$ years came under judgment because of disobedience to God's law. The exact price for the sin of the first Adam was the life blood of the Second Adam. It would require that the Second Adam be like the first Adam in every way, but with faithfulness instead of disobedience. I would even go so far as to suggest that Jesus' appearance probably looked just like Adam. Of course, that would not be a legal requirement for the transaction, but it makes for a nice supposition.

Having come to this point in the observation of God's time pattern regarding man's responsibility to God and his corresponding trial and judgment, it is now time to put some numbers on the graphic. For this exercise, it is required to go from the known to the unknown. But if enough of the numbers are known, the remainder can be obtain through simple arithmatic.

We know from the Biblical record, and from other historical records, and from the astronomical facts (see Appendix I), that the birth of Jesus was September 29, 2 B.C. From the same above mentioned data, we also obtain the date of His death – April 3, 33 A.D. Also, through the Biblical, historical and astronomical records we can obtain the date when David was anointed king over all Israel, as well as the date of his death. These are suffi-

cient data from which we can obtain the rest of the needed dates to place in the graphic.

First, let's do the math. Knowing that Jesus was born in the autumn of 2 B.C., we count back 4,000 years and we arrive at autumn 4002 B.C. for the date of the creation of Adam. This occurred near the end of the sixth Creation Day.

$$
\begin{array}{r}
\textbf{2 B.C.} \\
\underline{\textbf{+ 4000 years}} \\
\textbf{4002 B.C.}
\end{array}
$$

Next, we'll compute the 4,000 years back from His death. He died in the spring of A.D. 33. Counting 4,000 years back from that date brings us to the spring of 3968 B.C. It is the date when sin entered and Adam was driven out of the Garden. Note that when we cross the B.C.-A.D. divide, we must adjust for 1 year because our Gregorian system of years goes from 1 B.C. to 1 A.D. without a zero year between.

$$
\begin{array}{r}
\textbf{4000 years} \\
\underline{\textbf{- 33 A.D.}} \\
\textbf{3967} \\
\underline{\textbf{+ 1 (for adjustment)}} \\
\textbf{3968 B.C.}
\end{array}
$$

Counting forward 2,000 years from 2 B.C. brings us to the autumn of A.D. 1999, making the adjustment for the B.C.-A.D. divide. It brings us to the end of the 6,000 years that was given to man for rulership. It marks the year when man's right of rulership expires – not necessarily the time when his rulership ends. He does not give it up willingly. It will be taken from him by the One whose right it is.

Counting forward 3,000 years from 2 B.C. brings us to the autumn of 2999 as the end of the seven thousand years from the creation of Adam, and marks the beginning of the *"Little Season"* in which Satan is loosed from the bottomless pit and permitted to deceive the nations for the final test and judgment. The pattern tells us that this *"Little Season"* will be for a period of 33$\frac{1}{2}$ years, at the end of which *"The devil that deceived them was cast into the lake of fire and brimstone, where the beast and the false prophet are,"* (Revelation 20:10.

This gives us the basic outline of the whole chronology of man, from the creation of Adam to the time when all that Adam lost through disobedience will be restored to man.

Adam had been created perfect. He had been given a perfect environment in which to live. And he had been made ruler over all the earth.

"So God created man in his own image, in the

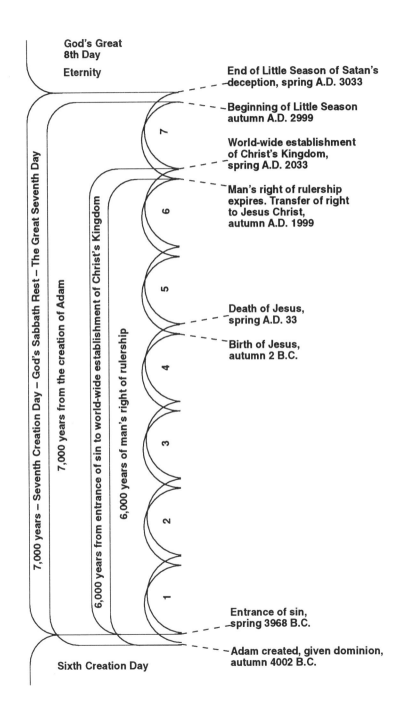

God's Great
8th Day

Eternity

End of Little Season of Satan's
deception, spring A.D. 3033

Beginning of Little Season
autumn A.D. 2999

World-wide establishment
of Christ's Kingdom,
spring A.D. 2033

Man's right of rulership
expires. Transfer of right
to Jesus Christ,
autumn A.D. 1999

Death of Jesus,
spring A.D. 33

Birth of Jesus,
autumn 2 B.C.

Entrance of sin,
spring 3968 B.C.

Adam created, given dominion,
autumn 4002 B.C.

7,000 years – Seventh Creation Day – God's Sabbath Rest – The Great Seventh Day

7,000 years from the creation of Adam

6,000 years from entrance of sin to world-wide establishment of Christ's Kingdom

6,000 years of man's right of rulership

Sixth Creation Day

image of God created he him; male and female created he them. And God blessed them, and God said unto them, Be fruitful, and multiply, and replenish the earth, and subdue it; and have dominion over the fish of the sea, and over the fowl of the air, and over every living thing that moveth upon the earth.... And God saw everything that he had made, and, behold, it was very good." (Genesis 1:27-31)

The kingship that was given to man in the Garden of Eden on the sixth creation day will be restored to him at the end of the seventh creation day – God's sabbath of rest. This was the purpose for which Jesus came to earth and died – to restore to man all that Adam had lost.

"And there shall be no night there; and they need no candle, neither light of the sun; for the Lord God giveth them light: and they (mankind) *shall reign for ever and ever....And the Spirit and the bride say, Come. And let him that heareth say, Come. And let him that is athirst come. And whosoever will, let him take of the water of life freely."* (Revelation 22:5 & 17)

4

The Year 1999 and 5760

Rosh Hashanah, the Hebrew civil New Year's Day, occurred on September 11, 1999. It was the first day of the Hebrew year 5760. It marked the end of 6,000 years of man's right to rule, and its transfer to *"Him whose right it is,"* Jesus Christ, the antitypical David, King Messiah.

Thus Rosh Hashanah of 5760 became a pivotal point in the history of man. It brought to an end 6 "days" of man's experiences here on earth, and marked the beginning of the 7th thousand-year "day." Using the Hebrew spelling for "six days" as it appears in the Masoretic Text, we can assign the number values for each letter, then multiply those numbers. The answer is absolutely amazing! It produces 5760 followed by many zeros, which can be dropped. (Read it from right to left.)

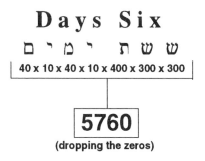

D a y s S i x

ם י מ י ת ש ש

| 40 x 10 x 40 x 10 x 400 x 300 x 300 |

5760

(dropping the zeros)

Would this remarkable demonstration of Gematria reveal the message that God had put into it from the beginning – telling us that the Hebrew year 5760 would mark the end of 6,000 years of man's right to rule? It appears to be so! It appears that the surface text is telling us that man will have 6,000 years, and the encoded message (Gematria) in the text is telling us the very same thing, even naming the year in which it will end.

In the Torah, in Numbers chapters 3 and 4 we find another encoded message, this time from the ELS Code (Equidistant Letter Sequence). It appears to be telling us that the "appointed time" for "man's days" would bring us to the year 5760 – a period of 6,000 years. For clarity, only the words involved in the code are shown.

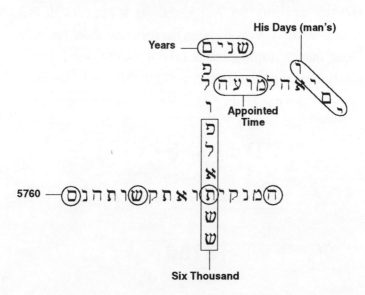

This remarkable matrix suggests that the *"appointed time"* for *"man's days"* would produce 6,000 years, bringing us to the year 5760.

Thus it appears that man's lease of rulership expired on Rosh Hashanah of 1999. But man is definitely still ruling, and still making a mess of it. I suggest that he is no longer ruling by divine right, but by usurpation, and will soon be dethroned by the One to whom it rightfully belongs.

Psalm 2 depicts this period of transition from the kings of this earth to King Messiah.

> *"Why do the heathen rage, and the people imagine a vain thing? The kings of the earth set themselves, and the rulers take counsel together, against the Lord, and against his anointed* (Messiah), *saying, Let us break their bands asunder, and cast away their cords from us. He that sitteth in the heavens shall laugh: the Lord shall have them in derision. Then shall he speak unto them in his wrath, and vex them in his sore displeasure. Yet have I set my king upon my holy hill of Zion."*

The indication in this text is that when King Messiah takes the appointed rulership of earth, it is followed by the time of the wrath of God against those kings and

rulers whose time has expired. But notice something important here. He says *"I have set my king."* Putting it past tense in relation to the time of the wrath. This Psalm is telling us that the transfer of right of rulership occurs first, and is followed by the wrath of God against those nations and kings whose lease of power has expired. It is also telling us *when* that lease of power expires. It is encoded into the text by the Number Code.

The phrase *"I have set my king"* is the key to the time element of the prophecy. If we assign the correct numbers to each Hebrew letter in this phrase, and then multiply those numbers, they will produce the number 5760 with additional zeros which can be dropped. The Hebrew text is telling us *when* the new King would move into the position of power. It is the Hebrew year 5760. And that new ruler is none other than the One whom the prophet Daniel described as *"Messiah the Prince."* And whoever wrote the book of Daniel used Hebrew letters for this title which multiply to 5760.

5760 = I have set my King (by multiplication)
5760 = Messiah the Prince (by multiplication)

This appointed time for King Messiah to take His rightful place as earth's new ruler is at the expiration of 6,000 years from the time when dominion was given to Adam in the Garden of Eden. Messiah's rulership

begins at the beginning of the Hebrew year 5760. And amazingly, the prophet Zechariah, when speaking of the coming of Messiah, used the expression, *"Behold, your King."* (Zech. 9:9) Would you believe, if we multiply the number values of the Hebrew letters in this phrase, it will produce 6000. It was no mistake. It was no accidental coincidence. It was a message, encoded into the text that is telling us that Jesus will become earth's new King at the expiration of the 6,000 years of man's allotted rule.

In the New Testament there are three Greek terms that refer to this rulership, and each of them multiply to 6000:

6000 = King
6000 = Kingdom
6000 = Head (meaning Jesus)

The reality is spectacular in its scope, and profoundly simple in its mathematics. It becomes apparent that precisely in the middle of this 6,000 years of man's rulership, God appointed David to be the king over His typical kingdom. I say "typical" because it was a foreshadow of the great Kingdom of Jesus Christ which will rule over man during Earth's Great Millennium. The very existence of David's kingdom points to the reality of the Kingdom of Jesus Christ (the antitypical David).

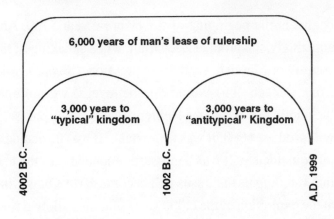

6,000 years of man's lease of rulership

3,000 years to "typical" kingdom

3,000 years to "antitypical" Kingdom

4002 B.C.

1002 B.C.

A.D. 1999

David's 33½ years were spent in subduing and conquering his enemies. Just prior to his death he turned the kingdom over to his son Solomon, who reigned in peace. Similarly, we can probably expect a parallel period of 33½ years from the date of the transfer of rulership to the time when the nations are fully subdued and brought into the peaceful Kingdom of Jesus Christ. For this is what both Isaiah and Micah have prophesied.

> *"It shall come to pass in the last days, that the mountain of the Lord's house* (Christ's Kingdom) *shall be established in the top of the mountains* (above the other nations of the world), *and it shall be exalted above the hills* (smaller nations); *and all nations shall flow unto it. And many people shall go and say, Come ye, and let us go up to the mountain of the Lord, to the house of the God of Jacob;*

and he will teach us of his ways, and we will walk in his paths: for out of Zion shall go forth the law, and the word of the Lord from Jerusalem. And he shall judge among the nations, and shall rebuke many people: and they shall beat their swords into plowshares, and their spears into pruninghooks: nation shall not lift up sword against nation, neither shall they learn war any more." (Isaiah 2:2-4)

It is a beautiful promise, and we are living in the time when this transition of rulership is happening. But before the promised peace can be effective world-wide, the nations must be subdued and come to the seat of that new government, Jerusalem, to receive the blessings it has to offer.

Note in the graphic on the opposite page, there appears to be 3,000 years from King Adam to King David, and another 3,000 years from King David to King Jesus. These time periods were evidently known before the time of Jesus' first advent. An ancient manuscript, which has been entitled *II Esdras,* was written sometime during the first century before Christ, with its first and last chapters having been added by a later writer sometime during the first century of the Christian era. In this manuscript the writer describes an encounter with an angel named Uriel who told him that there had been 3,000 years between

the time of Adam and the time of David. We have no way of knowing for sure whether the writer of this was simply making a good story, or if an angel named Uriel did indeed speak to him. Either way, the information is valuable, because it reflects the knowledge that was available to the writer at that time. And it is in complete harmony with the known facts.

By dividing these 3,000-year periods into thousand-year "days," it is easy to see that since the autumn of 1999 we have entered the third day from Jesus' first advent.

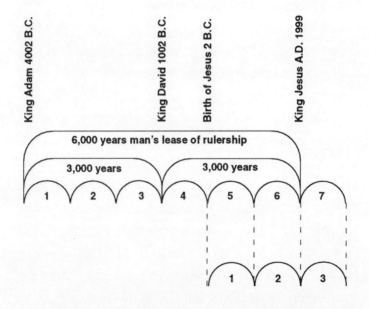

From the above graphic it becomes apparent that the third day and the seventh day are one and the same

period of time, and they are indeed spoken of in the Bible in this way. Since the third day and the seventh day are prophesied to be the same period of time, it helps to confirm the chronology. If we separated them the chain of chronology would be broken and none of the analogies described thus far in this book would fit.

Not only does the sameness of the third day and the seventh day confirm the chronology, this sameness is also displayed in the Gematria.

The great third day and the great seventh day both begin at the same point in time, namely, Rosh Hashanah of 1999. This date marks the end of 6,000 years, or six days, from the creation of Adam. It was thrilling to find that the Gematria for "six days" is exactly the same as the Gematria for "third day." Both bear the number 5760. They are both pin-pointing the same day in time – Rosh Hashanah of the Hebrew year 5760. And, as if we are being prompted not to miss this remarkable display of harmony in the Number Code and in chronology, the term "third day" in the New Testament also shouts at us with the same number – 5760. Two completely different spellings of "third day" and in two different languages, using two different alphabets, both produce the same number, 5760. I suggest it goes far beyond the idea of blind coincidence, and into the realm of evidence of a Divine hand in its planning. It is shouting at us the grand and wonderful message that the six days of man's

dominion end at the beginning of the Hebrew year 5760, and there the great third day and seventh day begin.

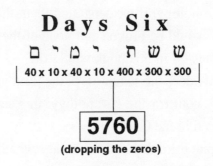

Days Six

ש ש ת י מ י ם

40 x 10 x 40 x 10 x 400 x 300 x 300

5760

(dropping the zeros)

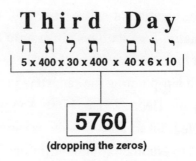

Third Day

ה ת ל ת ם ו י

5 x 400 x 30 x 400 x 40 x 6 x 10

5760

(dropping the zeros)

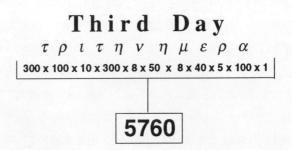

Third Day

τ ρ ι τ η ν η μ ε ρ α

300 x 100 x 10 x 300 x 8 x 50 x 8 x 40 x 5 x 100 x 1

5760

This great third day and seventh day is, in fact, a Sabbath. The six days of man's dominion are followed by the seventh day, which is a Sabbath. It is not surprising, therefore, to find the expression *"on the Sabbath Day,"* in the Hebrew text, also bears the number 5760 by multiplying its letter-numbers. And, since that date on the Hebrew calendar marks the time when *"I have set my King"* upon the holy hill of Zion, it is not surprising to find that also multiplies to 5760. Daniel called him *"Messiah the Prince,"* which also multiplies to 5760.

When we list all of these together they reveal a powerful message – that the Hebrew year 5760 is the appointed, forordained time when *"I have set my King,"* (5760) who is *"Messiah the Prince,"* (5760) upon the throne of David. It happens at the end of *"six days"* (5760) and *"on the Sabbath Day,"* (5760) which is the *"third day"* (5760) from the birth of this promised King. Let me catch my breath! Is it really that plain in the Bible? Yes!

5760 = **Six Days,** ששת ימים

5760 = **Third Day,** יום תלתה

5760 = **Third Day,** τριτην ημερα

5760 = **On the Sabbath Day,** ביום השבת

5760 = **I have set my King (Psalm 2:6),** נסכתי מלכי

5760 = **Messiah the Prince (Daniel 9:25),** משח נגיד

5760 = **The Kingdom, (Daniel 7:27),** מלכות

This scenario of six days followed by the "third day" (the seventh day) is given to us in the Gospel of John. This gospel is very different from the three that precede it in our Bible. Matthew, Mark and Luke all told basically the same story, however, John takes a totally different approach, and tells us many things that the three other gospel writers never mentioned. An analysis of John's gospel reveals that he must have been giving us a hidden time measurement, and a hidden time sequence, in his descriptions of the miracles that Jesus performed.

John describes in detail only seven miracles during the ministry of Jesus, between His baptism and His death. It is evident that many more miracles were done, but only these seven are told by John. Only one of these seven is mentioned by the other gospel writers. John relates these as "signs." ("Signs" in Hebrew has a Gematria of 576 by addition.)

He begins this sequence by saying *"The next day"* (John 1:29) but does not tell us where he is beginning the count. Therefore, we must begin *"the next day"* as day two of the sequence. In verse 35 he says *"the next day"* – this would be day three. Verse 43 says *"the day following"* – this would be day four. Then chapter 2 begins with *"And the third day there was a marriage in Cana of Galilee."* Now wait a minute. What kind of counting is that?

John enumerated four days, then skipped numbers

five and six, and told us what happened on the seventh, but instead of calling it the seventh, he called it the third. Why? Because the seventh day and the third day are one and the same. John was about to tell us of a great event that would happen on the great third day.

"And the third day there was a marriage in Cana of Galilee." (John 2:1) It was the day when six earthen waterpots were filled to the brim with water, and then Jesus turned the water into wine. It is a picture of the great seventh day when the marriage of Jesus and His Bride takes place. But it is said to have happened *"on the third day."*

In the Torah we were given the law of uncleanness and purification after a person had touched a dead body. The ashes of a red heifer were used for this purification process. *"He shall purify himself with it on the third day, and on the seventh day he shall be clean."* (Numbers 19:12) This connection of the third day and the seventh day is again expressed in verse 19, *"And the clean person shall sprinkle upon the unclean on the third day, and on the seventh day he shall purify himself, and wash his clothes, and bathe himself in water, and shall be clean at even."*

This connection between the third day and the seventh day is a vital key in understanding the whole chronology of man. The reason is simple. If the third day from the birth of Jesus brings us to Rosh Hashanah of

the Hebrew year 5760, and if this is also the seventh day from the creation of Adam, then simple arithmatic tells us that four days had to precede His birth. And since the "days" we are counting from his birth are thousand-year days, then the four "days" preceding must also be thousand-year days, taking us back to the year 4002 B.C., and thus producing 6,000 years from the creation of Adam to Rosh Hashanah of 5760.

The concept that the third day and the seventh day are one and the same day is the "nail" that fastens the whole chronology of man. To use a common metaphor, we could say that it "nails it down."

Actually, that metaphor is very ancient. As I mentioned previously, the Hebrew alphabet not only has the function of sound – phonetics – but it also has the function of quantity – number. And it has a third function. Each letter of the Hebrew alphabet has a meaning – it represents something.

The sixth letter of the Hebrew alphabet is Vau. It is sometimes written as Vaw, and sometimes as Vav. It is used as a conjunction. It connects. It translates to the word "and." In ancient Hebrew the letter Vau had the meaning of a "nail." Its shape was that of a nail. A nail has primarily the function of fastening two or more things together, making them all one piece. It also has the function of a peg that is driven into the wall and used for hanging important items.

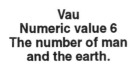
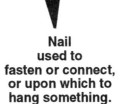

Vau
Numeric value 6
The number of man
and the earth.

Nail
used to
fasten or connect,
or upon which to
hang something.

The number six is the fastener, or the connector, thus the 6,000 years of man comes to an end with Rosh Hashanah of 1999, at which point the great third day and the great seventh day begin. It is the peg upon which we hang the entire chronology of man.

The chronology of man cannot be separated from the fact that there are 2,000 years from the birth of Jesus to Rosh Hashanah of 1999. It cannot be separated from the third day that follows the 2,000 years. It cannot be separated from the Sabbath that follows the six days. It cannot be separated from the great seventh day, which is also the third day. *There* is the nail. It connects and fastens the chronology! *There* is the peg upon which we hang the entire chronology of man!

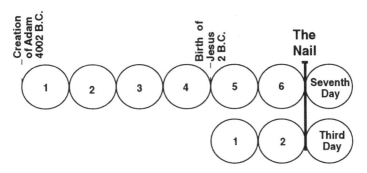

The same principle is displayed with the great seventh creation day, which began at the end of the sixth creation day, the point in time where Adam sinned and was banished from the Garden. It measures 4,000 years from the entrance of sin to the atonement for sin, and another 3,000 to the end of the Little Season and the beginning of the great 8th day of Eternity. In doing so, the nail comes down at A.D. 2033.

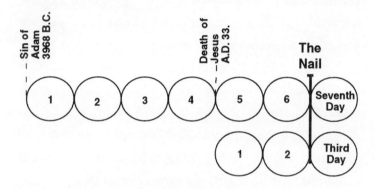

The 4,000 years from the entrance of sin to the atonement for sin is pictured in the death and resurrection of Lazarus. He was in the grave four days, picturing the 4 thousand-year days in which mankind was held under the death penalty without a redeemer. At the end of 4,000 years, Jesus paid the price for the sin of Adam, and provided mankind with an opportunity for life.

5

The Pilgrim Festivals

The purpose of this book is to find a method of counting that will confirm the year-by-year method. It is sort of like double-entry bookkeeping. It checks itself and the errors become obvious. I have not abandoned the year-by-year method. It can be found in Appendix II. But for our purposes here, I am attempting to find long eras of time that jump over the details, yet confirm them.

Such long eras of time can be found in the Feasts of Israel. These feasts numbered seven, and covered a space of seven months – although not evenly spaced by any means. These seven months are God's "Week of Months," beginning with Nisan in the spring and ending with Tishri in the autumn. It is sometimes called the Sacred Year.

The seven festivals are:

1. **Passover, (Nisan 14)**
2. **Unleavened Bread, (Nisan 15-21**
3. **Firstfruits, (Nisan 16)**
4. **Pentecost, (Sivan 6)**
5. **Trumpets, (Tishri 1)**
6. **Atonement, (Tishri 10)**
7. **Tabernacles, (Tishri 15-21)**
 Followed by an eighth day celebration called "The *Atzereth*" meaning "conclusion."

Three of these feasts were to be celebrated in a special way. All the males were to present themselves to God. The instruction was given to Moses and recorded in the Torah.

> *"Three times thou shalt keep a feast unto me in the year. Thou shalt keep the feast of unleavened bread ... And the feast of harvest, the firstfruits of thy labours, which thou hast sown in the field: and the feast of ingathering, which is in the end of the year, when thou hast gathered in thy labours out of the field."* (Exodus 23:14-16

> *"Three times in a year shall all thy males appear before the Lord thy God in the place which he shall choose; in the feast of unleavened bread, and in the feast of weeks, and in the feast of tabernacles."* (Deut. 16:16)

The Feast of Unleavened Bread includes the Passover and the Firstfruits. The Passover lamb was to be killed at 3:00 in the afternoon on Nisan 14, but not eaten until after 6:00 p.m. with the start of the 15th; and the presentation of the firstfruits was on the 16th, thus the whole celebration was called by the general term of "Feast of Unleavened Bread" but it begins with the killing of the lamb.

These three feasts came to be known as Pilgrim Festivals because those who lived in other cities and even in other countries, came to Jerusalem to celebrate and to present themselves to God at the Temple.

But, what has this to do with the time-line of man's experience with sin? It has everything to do with it!

These three Pilgrim Festivals are types, or pictures, of three great epochs of time during man's experience with sin and the redemption from its penalties. And they confirm the time, to the year – yes, and even to the month.

The first Passover was in the spring of 1448 B.C. The Israelites were in bondage in Egypt, and pleaded with God to rescue them and set them free. God instructed Moses to go to the Pharaoh and ask to let the people go. Pharaoh, of course, was not willing, because he was using them for free labor to build his treasure cities.

Finally, after ten severe disasters were poured out upon Egypt, the Pharaoh became reluctantly willing to let the Israelites go.

God instructed Moses to have each household take a lamb, and kill it on the afternoon of Nisan 14, at 3:00 in the afternoon. The blood from the lamb was to be spread over the doorframes of their houses, and the lamb was to be roasted with fire and eaten during the night. A "death angel" was to pass through the land that night, and slay all the firstborn who were not in a house with blood on the doorframe.

When the "death angel" saw the blood on the doorframe, he would "pass over" that house, and not kill the firstborn. Thus the event came to be known as the Passover.

When daylight came, the Israelites, under the leadership of Moses, began moving out of their houses and prepared to leave Egypt.

It was a "type" of great things to come. Exactly 1,480 years later, the Lamb of God was killed at 3:00 in the afternoon of Nisan 14. It was His body that had been pictured by that lamb back in Egypt. It was His blood that had been pictured by the blood on the doorframes of the houses. He was the fulfillment of the type. He was the great Passover Lamb. And it is His blood that saves all those who are "under" the blood.

Thus we could call the 1,480 years from the first Passover to the death of Jesus, the "Passover Age." It is an era of time during which a specific thing would be accomplished. And that was the type and the antitype of the Passover.

Even the Gematria tells us that this period of 1,480 years was a planned period of time. The word "Passover" in Hebrew, when we add its number values, bears the number 148.

The Apostle Paul made the connection for us. He said, *"Christ, our Passover, is sacrificed for us."* (I Cor. 5:7)

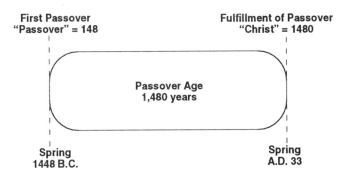

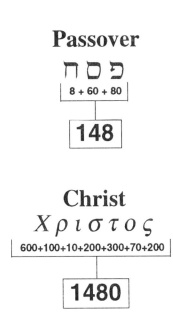

Passover

פ ס ח

| 8 + 60 + 80 |

148

Christ

X ρ ι σ τ ο ς

| 600+100+10+200+300+70+200 |

1480

The second Pilgrim Festival was on the 6th of the month Sivan. It was called the *"Feast of Weeks,"* but in New Testament times was called *Pentecost.* They were to count seven weeks from the day of Firstfruits, making 49 days, and the following day would be Pentecost.

On this day they went into the wheat field, which was newly ripening, and cut a measure of the firstripe wheat, removed it from the chaff, ground it to flour, and baked two small loaves, with leaven. which they presented to God.

This was done on the 6th day of the month Sivan, 50 days after the offering of the firstfruits of the barley harvest. The count from the day of Firstfruits was to be seven weeks, or 49 days. The following day would be the day of the offering of the firstfruits of the wheat harvest.

This began to have its fulfillment in the year A.D. 33, just 50 days from the resurrection of Jesus. It was the day of Pentecost, when a very special demonstration of God's power was given to the little band of disciples who were still in mourning and in bewilderment after the death of Jesus.

People from many other countries were in Jerusalem that day, because it was one of the Pilgrim Festivals, and they had come in response to the law that Moses had given to them, to present themselves to God at the Temple. And when they heard about the gathering of the disciples, they came to see what was going on.

What they witnessed was the espousal of the Bride of Christ. It came in the form of a pouring out of the Holy Spirit upon the disciples. Those who were teaching suddenly had the ability to speak in the languages of

all those who were in attendance. And there appeared over their heads what looked like tongues of fire. The people were in great astonishment at what they were seeing and hearing.

They each heard a discourse in their own language – a discourse telling them about the resurrection of Jesus. They were profoundly struck by the intensity of the words, and after they had heard all, they began to ask, *"What shall we do?"*

Peter said, *"Repent and be baptized, every one of you, in the name of Jesus Christ."*

"And they that gladly received the word were baptized: and the same day there were added unto them about three thousand souls." (Acts 2:41)

It was the beginning of a new age – the Pentecost Age. It was the beginning of the period of time that God had planned for the call and development of the bride of Christ. It began with the conversion of 3,000 people, probably all Israelites, for it was from among those who had come to celebrate the Pilgrim Festival of Pentecost.

The Passover Age had come to a close when Jesus hung on the cross, and shed his innocent blood in the place of the guilty blood of Adam. It had marked 4,000 years from the day when Adam sinned. Now a new age

was beginning. It was the Pentecost Age – an age that would last for 2,000 years. It was 2,000 years that had been set aside in the Plan of God for the call and development of a very special class – a bride for His Son.

But how do we know it is 2,000 years? Look at the type. On the *"morrow after the Sabbath"* they were to harvest the very first ripe barley, and wave it before God as an offering. This was the festival of the Day of Firstfruits. It corresponds to the day when Jesus was raised from the tomb and presented the merit of His sacrifice to God – into the hands of Justice. It was the presentation of the blood that was offered in payment for the sin of Adam. From this day they were to count 49 days, or seven weeks. Then the next day, the 50th, would be the time of harvesting the firstripe wheat, grinding it to flour, and making two small loaves, containing leaven, and wave it before God as an offering.

The antitype is always greater than the type. The antitype is the harvesting of the firstripe wheat (the church), and the presenting of its two parts to God. Those two parts consisting of the Israelite portion of the Bride, and the Gentile portion of the Bride.

When this law of the counting from the Day of Firstfruits to the day of Pentecost was given to Moses, it was not possible for them to observe it, because they were in the wilderness where there was no barley or wheat harvest. It was not until 40 years later that they were

able to fulfill this requirement of the Law, after they had crossed over the Jordan and into Canaan. Thus the suggestion that each of these days of counting from Firstfruits to Pentecost, in the antitype, would represent 40 years.

Another hint that each of these days represents a period of 40 years can be found in the length of time of the reign of Saul, Israel's first king. His reign, in some aspects, represents the development of the Church. He began his reign in humility and sincerity of purpose, but as he grew in power, he also grew in self-importance. It pictures the experience of the Church, which began in humility and sincerity, and in faithfulness to God. But as the years progressed, they became proud, and became the rulers of nations, until it became known as the Holy Roman Empire. It was the Church who crowned and uncrowned kings. It was the Church who persecuted those believers who still lived in humility and faithfulness, burning them at the stake, stretching them on the racks, and beheading them with the guillotine. And, after Saul had reigned for 40 years, he fell on his own sword and died. Thus will come the demise of the Church, who began as a small, faithful body of believers at Pentecost, but who grew to great power and unfaithfulness.

If we use the suggested 40 years as representing each of the 49 days of the counting from the Day of Firstfruits to the beginning of the Day of Pentecost, then it brings us to the year A.D. 1993 as the end of the count-

ing, making the next 40-year "day" correspond to the Day of Pentecost. Thus the great antitypical Day of Pentecost would be the 40-year "day" from the spring of 1993 to the spring of 2033.

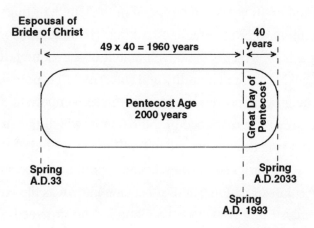

From the above graphic, it can be deduced that the consummation of the marriage would be sometime between the spring of A.D. 1993 and the spring of A.D. 2033, on the Great Day of Pentecost. This is why some suggest that the marriage takes place in the spring.

I suggest that more than one marriage takes place on this Great Day of Pentecost.

There was a marriage that took place in the spring of 1448 B.C., soon after Moses led the Israelites out of Egypt and into the wilderness.

It is stated in the Talmud that the Law Covenant,

given at Sinai, was in fact a Marriage Covenant. Israel considered herself married to God. That Law-Marriage Covenant was given to Moses on the Day of Pentecost in 1448 B.C. And, even though they were unable to celebrate the harvest of firstripe wheat, because there was no wheat to be harvested, the day, nevertheless, was a wedding day.

Although it is not specifically stated in the Bible that the Law was given to Moses on the day of Pentecost, it can be deduced. It is said that Moses ascended the mountain on the 2nd of Sivan, received the answer from the people on the 3rd, re-ascended the mountain on the 4th. He commanded the people to sanctify themselves three days, which were the 4th, 5th, and 6th; and on the third day, which was Sivan 6, he delivered the Law to them.

McClintock & Strong's Biblical Encyclopedia makes the following observation:

> ... though the canonical Scriptures speak of Pentecost as simply a harvest festival, yet the non-canonical documents show, beyond the shadow of a doubt, that the Jews, at least as early as the days of Christ, connected with it, and commemorated on the 6th of Sivan, the third month, the giving of the Decologue. It is made out from Exodus 19 that the law was delivered on the fiftieth day after the deliverance from Egypt. It has been conjectured

that a connection between the event and the festival may possibly be hinted at in the reference to the observance of the law in Deuteronomy 26:12.

The Book of Jasher is a very old document, having been written before the book of Joshua. This is known because Joshua 10:13 quotes a statement from the Book of Jasher. This ancient document says (Jasher 82:6 & 7):

> In the third month from the children of Israel's departure from Egypt, on the sixth day thereof, the Lord gave to Israel the ten commandments on Mount Sinai. And all Israel heard all these commandments, and all Israel rejoiced exceedingly in the Lord on that day.

The third month from Nisan is Sivan, and the 6th day of Sivan is *Shavout* (Pentecost). McClintock & Strong also makes an analogy between the day of the giving of the Law, and the day of Pentecost, when the Holy Spirit was given to the Church.

> It is not surprising that, without any direct authority in the Old Testament, the coincidence of the day on which the festival (Pentecost) was observed with that on which the law appears to have been given to Moses, should have strongly impressed the minds of Christians in the early ages of the

Church. The divine Providence had ordained that the Holy Spirit should come down in a manner, to give spiritual life and unity to the Church, on that very same day in the year on which the Law had been bestowed on the children of Israel which gave to them national life and unity. They must have seen that, as the possession of the law had completed the deliverance of the Hebrew race wrought by the hand of Moses, so the gift of the Spirit perfected the work of the Church in the establishment of his Kingdom upon earth.

Thus it is fitting that, just as the revelation of the Law on the day of Pentecost brought Israel into covenant relationship with God, so also the revelation of the Holy Spirit on the day of Pentecost brought the Church into covenant relationship with God through Jesus Christ.

That Law Covenant (marriage covenant) made with Israel in the spring of 1448 B.C. was a divine pledge to be Israel's provider and protector, conditional upon her faithfulness and obedience to Him. Israel said "I do" when they promised to keep all the requirements of the Law.

When Jesus came, the Jews were still making ritualistic attempts at living by the Law, and they were legally still responsible to its precepts and ordinances.

In the spring of A.D. 33, just prior to His arrest and

crucifixion, Jesus condemned the Pharisees and the teachers of the Law for being hypocrites, and said, *"Your house is left unto you desolate."* They were cast off. They were no longer a married woman, but were now *"desolate,"* forsaken, and left without a protector-provider. A few hours later, as Jesus hung on the cross, the moon eclipsed. The Law, represented by the moon, had lost its light. The Apostle Paul said that when Jesus died, the Law Covenant died with Him: *"He took it away, nailing it to his cross."* (Col. 2:14)

After 1480 years, the divorce was final. Within a few years their Temple was distroyed. The meeting place between God and man was gone. The place of atonement by animal sacrifice was gone. They were driven from their holy city and left desolate, to wander throughout the earth without a protector-provider.

The time of the marriage and the divorce are quite evident from scripture. But what about the re-marriage? When does that take place? Through the prophet Hosea God promised another marriage:

> *"In that day I will cut a covenant* (another marriage covenant) *for them ... and I will break the bow and the sword and the battle out of the earth, and I will make them to lie down safely. And I will betroth you to me forever. Yes, I will betroth you to Me in righteousness,*

and in judgment, and in mercy and in compas-
sion. I will even betroth you to Me in faithful-
ness. And you shall know Jehovah ... And I
will sow her to Me in the earth...." (Hosea
2:18-23 KJV-II)

God is describing to Hosea the time when He will
re-marry Israel. He also makes the definite connection
between the marriage at Sinai and the re-marriage:

"And I will give her her vineyards from there,
and the valley of Achor for a door of hope.
And she shall answer there (say "I do"), *as in*
the days of her youth, as in the day when she
came up out of the land of Egypt (at Mt. Sinai).
And at that day, says Jehovah, you shall call
Me, 'My husband.'" (Hosea 2:14-16 KJV-II)

Some have confused this with the marriage of Jesus
and His Bride, but they are two distinct marriages. God
is here describing a time when Israel will again be in a
covenant relationship with Him, just as she was when
she said "I do" at Mt. Sinai. The Church never said "I
do" at Sinai. This is descriptive only of the people of
Israel.

The Prophet Isaiah described the same event in un-
mistakable language:

"You no longer shall be called Forsaken; nor shall your land any longer be called Desolate; but you shall be called 'My Delight is in Her'; and your land shall be married; for Jehovah delights in you and your land shall be married." (Isaiah 62:40)

There never was a time when the Bride of Christ was called *"Forsaken"* and there never was a time when she was called *"Desolate."* No, it is not talking about the Bride of Christ – it is talking about God's re-marriage to Israel, whom He had divorced so that she had become *"Forsaken"* and *"Desolate."* But He makes this beautiful promise to her that she shall never again be called *"Forsaken"* or *"Desolate,"* and that her land will be returned to her and it shall be part of the marriage covenant.

There are many scriptures, in addition to the few quoted above, regarding the event of God's re-marriage to Israel. One of them is the well-known promise in Isaiah 40:1.

"Speak to the heart of Jerusalem, and cry to her that her warfare is done, that her iniquity is pardoned, for she has received from Jehovah's hand double for all her sins." (KJV-II)

This prophecy contains its own time-line by its remarkable Gematria. The sentence, *"Speak to the heart of Jerusalem and cry to her that her warfare is done, that her iniquity is pardoned,"* has a number value of 1999. And if we go back to Genesis 6:18 we find another remarkable indication of the time-line for the establishing of the covenant. God had said to Noah, *"I will establish my covenant with you."* It has a number value of 1999.

If Israel's divorce was final in the spring of A.D. 33, then 1999 years from then would bring us to the spring of 2032, which is one year from the end of the great antitypical Day of Pentecost. It appears that during the final year of man's 6,000 years from the entrance of sin, the final event will be God's re-marriage to Israel. It would be in the 2000th year from the event of the divorce.

It is interesting that this promise to Noah is in Genesis 6:18, and the Gematria of the instruction in Isaiah 40:1 to speak to *"The heart of Jerusalem"* also has a number value of 618. The number .618 is the Golden Proportion which plays a very important role in confirming the time-line of man, as will be discussed in the next chapter.

The long time-span from the birth of Noah to the establishing of the covenant of re-marriage with Israel is a period of 4944 years. If we were to divide those 4944

years by the Golden Proportion (.618) the result will be 8000. The number 8 in scripture always has reference to a New Beginning. In fact, the Gematria for the word "beginning" in Hebrew is 8. The name Noah means "rest." The re-marriage will be a glorious new beginning for Israel. It will finally be rest for the people after their wanderings in exile, because their sins will have been pardoned through Jesus Christ.

But the number 8 has a deeper significance than just the new beginning. It is a new beginning because of and through Jesus Christ. The name Jesus, in Greek, is *Iησους,* and its number value is 888. And when God gave to Isaiah the prophecy concerning the time of Israel's rest, He said, *"She has received of Jehovah's hand double for all her sins."* (Isaiah 40:3) If we add the number values of all the Hebrew letters in that promise, the total will be 888.

The connection between Noah and the bringing of rest to Israel can be observed through the Gematria:

888 = Jesus

888 = She has received of Jehovah's hand double for all her sins.

8880 = An ark, in which few, that is eight souls were saved through water (I Peter 3:20)

8880 = Behold a virgin shall conceive and bear a son, and shall call his name Emmanuel, which being interpreted is God with us. (Matthew 1:23)

Isaiah used much descriptive language when telling of the future time when Israel would be re-married to God. In chapter 52:9-10 he again speaks of the time of comfort to Israel: *"Jehovah comforts his people, he has redeemed Jerusalem. Jehovah has bared his holy arm in the eyes of all nations; and all the ends of the earth shall see the salvation of our God."*

888 = Salvation of our God

This salvation of Israel begins when Jesus returns with His Bride to put an end to Armageddon and turn back Israel's enemies. That will possibly be sometime during the years 2006-2007. And that salvation continues through the beginning of the setting up of Christ's Kingdom in Jerusalem, and establishing a government of peace. It will be followed by a time of conversion, which will lead to Israel's return to God. This salvation – or saving – of Israel will reach its fullness with the re-marriage to God in the spring of 2032-2033.

God's re-marriage to Israel will restore the intimate relationship that they once enjoyed. That relationship was a direct communication between God and Israel. In the past, this was by means of the *Urim* and *Thummim* which the High Priest wore over his heart. It was his means of

communication with God. But the *Urim* and *Thummim* were lost long before the divorce – probably at the time of the destruction of Jerusalem and the burning of the Temple.

When some of the captives from Judah returned to Jerusalem, after many years of desolation, they were aware that they lacked the means of direct communication with God. The governor (probably Nehemiah) suggested that they would have to wait until there stood up a priest who had the *Urim* and *Thummim.* The Hebrew text of Ezra 2:63 reads: *"A priest with Urim and Thummim,"* and its number value adds to 888.

The Priest for whom they must wait was identified by the Gematria. It was prophetic of Jesus, for it bears His number. It will be through His redeeming blood, and through their acceptance of Him, that they will once again enjoy an intimate communication with God, their Husband.

Thus the Golden Proportion connects the *rest,* typified by Noah, with the *rest* that Israel will experience when they are re-married to God. It also connects the loss of the *Urim* and *Thummim* to the return of *"a Priest with Urim and Thummim."* If these jewels had been lost at the time of the destruction of Jerusalem and the burning of the Temple in 586 B.C., there would be 2618 years until they once again enjoyed that precious communication with God. This number, when multiplied by the

abreviated Golden Proportion, produces the complete
Golden Proportion.

586 B.C.
2033 A.D.
2619
** - 1 Adjustment for zero year**
2618 years

2618 ÷ .618 = 1618

1:618 complete Golden Proportion
.618 abreviated Golden Proportion

As was shown on page 67, Isaiah's message in chapter 40:1 was to *"Speak lovingly to the heart of Jerusalem ... cry to her that her warfare is done, that her iniquity is pardoned; for she has received of Jehovah's hand double for all her sins."* What a beautiful text! Look at the amazing Gematria it holds!

618 = The heart of Jerusalem

888 = She has received of Jehovah's hand double for all
 her sins.

888 = Jesus, *Ιησους*

Yes, it was Jesus, whom they had rejected, who will be to them *"a Priest with Urim and Thummim."* It is He to whom they will turn, when they *"look upon Him whom*

they pierced, and mourn for him as for an only son," (Zechariah 12:10).

But what does it mean that *"she has received of Jehovah's hand double for all her sins?"* And why does this phrase bear the number of Jesus?

The number of years from the time of their first marriage, at Sinai in 1448 B.C., to and including the year of the re-marriage is 3,480. Could this figure be a "double" of something? Very probably!

By dividing 3,480 years by 2, we obtain two periods of 1,740 years each. This number tells us that it is Jesus who will be the means of their salvation. When viewing this calculation, remember that in Gematria zeros have no meaning of themselves, and can be dropped or added without changing the meaning of the numbers involved.

174 = Unto us a child is born (Isaiah 9:6) (This was prophetic of the birth of Jesus."

1740 = He comes as a tender plant before him, and as a root out of dry ground (Isaiah 53:2) (This is also prophetic of Jesus, at the time of his death.)

$$\begin{array}{r} 174 \\ + 1740 \\ \hline 3480 \end{array}$$

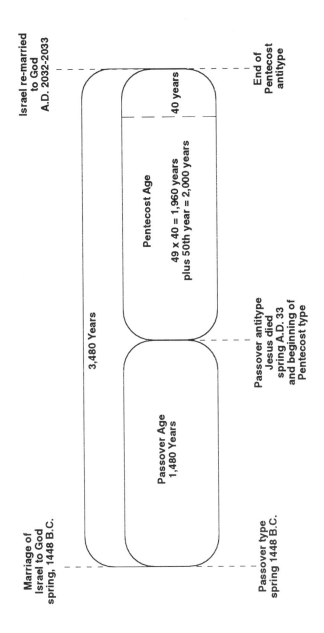

Marriage of Israel to God spring, 1448 B.C.

Israel re-married to God A.D. 2032-2033

3,480 Years

Passover Age 1,480 Years

Pentecost Age

49 x 40 = 1,960 years plus 50th year = 2,000 years

40 years

End of Pentecost antitype

Passover antitype Jesus died spring A.D. 33 and beginning of Pentecost type

Passover type spring 1448 B.C.

348 = The pleasant land (Jerusalem), (Zechariah 7:14)

348 = Anoint, משח

348 = Joy (to make glad), משח

Surely, after 3,480 long years, Jerusalem will indeed be made glad when they are anointed with *"the oil of gladness."*

> *"He who scattered Israel will gather them and will watch over his flock like a shepherd. For the Lord will ransom Jacob and redeem them from the hand of those stronger than they. They will come and <u>shout for joy</u> on the heights of Zion; they will rejoice in the bounty of the Lord – the grain, the new wine and the oil, the young of the flocks and herds. They will be like a well-watered garden, and they will sorrow no more. Then maidens will dance and be glad, young men and old as well. I will turn their mourning into <u>gladness</u>; I will give them comfort and <u>joy</u> instead of sorrow."* (Jeremiah 31:10-13 NIV)

This brings to its conclusion the 40-year Great Day of Pentecost, which follows the counting of 49 x 40 years. It appears to be the great "wedding day." I say that, because there is another wedding that takes place during this 40-year "day."

*"Let us be glad and rejoice, and give honour
to him; for the marriage of the Lamb is come,
and his wife hath made herself ready. And to
her was granted that she should be arrayed in
fine linen, clean and white: for the fine linen
is the righteousness of saints. And he saith unto
me, Write, Blessed are they which are called
unto the marriage supper of the Lamb. And he
saith unto me, These are the true sayings of
God."* (Revelation 19:7-9)

Immediately after seeing this vision of the marriage
of the Lamb, John saw another vision that was not so
beautiful. He saw a white horse with its rider, and a large
company following, all wearing white robes. They came
to make war upon the nations of earth. By comparing
the prophecies of the Old Testament with this vision of
John, we come to realize that these nations of earth are
the enemies of Israel, and they have come to annihilate
her.

The One riding the white horse is identified as Jesus,
for He had a name on His side that read *"King of kings
and Lord of lords."* And obviously the company of horse-
men that follow Him, all wearing white robes, is none
other than His bride, whom He had just married. Together
they come to destroy Israel's enemies. Thus it gives a
hint at the time element. It causes the time setting for

this wedding to be prior to the destruction of Israel's enemies.

A similar vision that John recorded told of ten kings that would come together in a pact with the beast, and they would make war with Jesus and His bride.

> *"These shall make war with the Lamb, and the Lamb shall overcome them: for he is Lord of lords, and King of kings: <u>and they that are with him are called, and chosen, and faithful.</u>"* (Revelation 17:14)

If the *"called, and chosen, and faithful,"* are with Him when He makes war with the final ten-nation union with the beast, then the marriage of the Lamb must precede this event.

This narrows the time down to only a few choices. The ten-nation union is with us today, in the form of the European Union. Its union with the beast is in formation as we speak.

It was in the summer of 1967 that the little nation of Israel gained the Old City of Jerusalem. If that was the fulfilling of the "Fig Tree" putting forth leaves, then their period of trial and testing (40 years) would come to an end in 2007. It would possibly be the time when Jesus would begin to set up His Kingdom of righteousness in Jerusalem. In order to set up His Kingdom, the enemies

must first be subdued. And the scriptures are clear, that His bride is with Him, and the wedding has taken place, when He comes to destroy Israel's enemies.

It leaves a small window of time. And somewhere, during that small window of time, the marriage of the Lamb will take place. It falls within the great antitypical Day of Pentecost. Thus the 40 years between 1993 and 2033 appears to be the Great Wedding Day. The first wedding is the *"marriage of the Lamb,"* and the second is God's re-marriage to Israel.

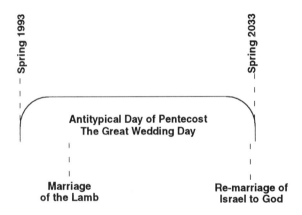

The third of the Pilgrim Festivals was the Feast of Tabernacles. This was a very joyous occasion. It was the final celebration of their Sacred Year. It was also called the Feast of Ingathering, because it came at the close of the final harvest of all their crops

This festival lasted seven days, and in Hebrew

liturgy it became known as "The season of our joy." It is an illustration of Earth's Great Millennium, at the close of which, man will be fully reconciled to God.

It was called the Feast of Tabernacles because during that week the people were to build booths, or tabernacles, from boughs and branches, and live in them. It was sort of like camping out and having one grand party, with sharing of the good things from the harvest. It was also a time of the reading of the Law – the instruction in righteousness.

> *"Day by day, from the first day until the last day, he* (Ezra) *read the book of the Law of God. And they kept the feast seven days."* (Nehemiah 8:18)

The Prophet Isaiah was given a prophetic view of this great antitypical Feast of Tabernacles – Earth's Great Millennium. This is how he described it:

> *"And Jehovah of hosts shall make for all people a feast of fat things in this mountain* (His Kingdom); *a feast of wine on the lees, of fat things full of marrow, of wine on the lees well refined. And He will destroy in this mountain* (Kingdom) *the face of the covering* (death) *which covers all people, and the veil that is*

woven over all nations. He will swallow up death in victory! And the Lord Jehovah will wipe away tears from all faces. And he shall remove the reproach of his people from off all the earth – for Jehovah has spoken. And one shall say in that day, 'This is our God, we have waited for him, he will save us; this is Jehovah, we have waited for him; we will be glad and rejoice in his salvation.'" (Isaiah 25:7-9 KJV-II)

Zechariah prophesied concerning this same time, and said that all people would then celebrate the Feast of Tabernacles. He was showing us that this Feast of Ingathering is a foretaste of Earth's Great Millennium, when all mankind will be gathered to Jehovah.

"And the Lord shall be King over all the earth; in that day there shall be one God and his name one ... And it shall be that everyone ... shall go up from year to year to worship the King, the Lord of Hosts, and to keep the Feast of Tabernacles." (Zechariah 14 KJV-II)

Isaiah said of that Millennial "day":

"And you shall with joy draw water out of the wells of salvation. And in that day you shall

say, 'Praise Jehovah! Call on his name; declare his doings among the people; make mention that his name is exalted.'" (Isaiah 12:3 KJV-II)

The wells of salvation will be a spring of living water that will heal the effects of the sin that Adam brought into the world. The prophet Ezekiel (chapter 47) had a vision regarding this life-giving stream, that starts as a small rivulet, and finally becomes waters too deep and too wide to cross. This torrent finally runs into the Dead Sea, and heals its waters so that it is a live sea. It is a beautiful word picture of the water of life, flowing from the wells of salvation. And just as the prophecy of Zechariah described a day that would be light at evening, so too this ever increasing river of life, by the end of the Millennium, will be a torrent that floods the Dead Sea (man under the Adamic curse) and causes it to flourish with life. This river of life was provided by Jesus Christ.

Isaiah's description, *"Wells of Salvation,"* has a number value of 576. It is a number that beautifully depicts the work of salvation and the One who provides it.

576 = Wells of Salvation, מעיני הישועה

576 = Life, πνευμα

576 = Messiah the Prince, משיח נגיד (by
 multiplication.

576 = He shall appear in his glory, נראה כבכודו
 (by multiplication)
576 = His Kingdom, מלכות (by multiplication)

This is only a small sampling of the use of the number 576 in relation to the Millennial Kingdom. It is no surprise to find that the beginning of the Hebrew year 5760 was the completion of 6,000 years from the time when Adam was given dominion. Man's lease of rulership has expired. With the beginning of the Hebrew year 5760 that lease of rulership rightfully belongs to Jesus Christ, for He purchased it with His own precious blood. But not until the year 2033 A.D. will the nations be subdued under His righteous rule. Not until the two weddings have taken place, will the celebration of the Feast of Tabernacles begin. It will last for 1,000 years, and at its end will begin God's Great Eighth Day – eternity.

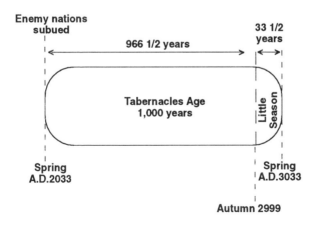

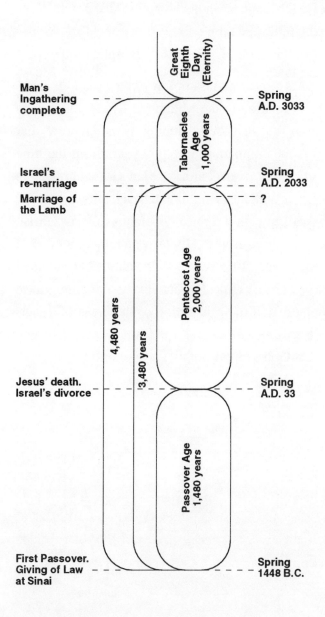

Man's
Ingathering
complete — — — — —

Great
Eighth
Day
(Eternity)

Spring
A.D. 3033

Tabernacles
Age
1,000 years

Israel's
re-marriage — — — — —

Spring
A.D. 2033

Marriage of
the Lamb — — — — —

?

4,480 years

3,480 years

Pentecost Age
2,000 years

Jesus' death.
Israel's divorce — — — — —

Spring
A.D. 33

Passover Age
1,480 years

First Passover.
Giving of Law — — — — —
at Sinai

Spring
1448 B.C.

The Feast of Tabernacles is a seven-day festival. After the seven days, they left the booths they had been living in, and returned to their homes to celebrate the great conclusion, the *Atzereth* – the great eighth day feast.

Philo, the Alexandrian, called this day "the crowning feast of all the feasts of the year." And indeed it was!

John records the event of a Feast of Tabernacles celebration in which Jesus participated.

> *"On the last and greatest day of the Feast, Jesus stood and said in a loud voice, 'If anyone is thirsty, let him come to me and drink."* (John 7:37 NIV)

It might seem a rather strange thing to say to a crowd who had no idea of its meaning. He was signifying that the Great Eighth Day is a day of obtaining life – eternal life – the kind of life that Adam had before he sinned. Jesus knew that He would be the provider of the *"water of life"* for all mankind. And He probably knew that the very words He chose would signify the time when that Great Eighth Day would begin. Surely it is no coincidence that the Gematria of the text adds to 3000. For He knew that it would be 3,000 years from the offering of Himself at Calvary to the beginning of the Great Eighth Day, when He will say, *"Whosoever will, let him take of the water of life freely."* (Revelation 22:17)

3000 = If anyone thirsts, let him come, εαν τις διψα
ερχεσθω (John 7:37)

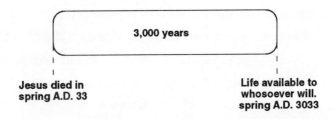

**Jesus died in
spring A.D. 33**

**Life available to
whosoever will.
spring A.D. 3033**

It is a positive link in the time-line that Jesus, Himself, gave to us. It serves to confirm the time presented thus far as being accurate.

It is interesting to realize that from the first day of the Sacred Calendar, Passover, on Nisan 14, to the end of the Feast of Tabernacles and the beginning of the Great Eighth Day is 186 days. It depicts the time, beginning with the Passover, when He hung on the cross, to the giving of life to whosoever will at the beginning of the Great Eighth Day. But why the number 186?

It is an anagram of the Golden Proportion, which, in its simplified version, is .618. The story that is told by these three numbers, 1, 6, and 8 is magnificent. These three numbers have to do with Beginning (1), Man (6), and New Beginning (8). When placed in the order of 618 they tell the whole story of the chronology of man. When placed in the order of 186 they tell the story of redemption and complete restoration.

The entire 7,000 years from the entrance of sin to the eradication of sin is a demonstration of 618 and 186. The numbers are absolutely amazing. Even if math is not your "thing" I urge you to witness the magnificent work of the Great Mathematician, and observe how He projected the whole story of the redemption of man from sin, by these three simple numerals – 1, 6 and 8.

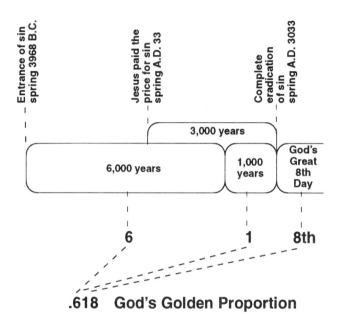

.618 God's Golden Proportion

Revelation 22:1 John saw in vision a pure river of the water of life, clear as crystal, flowing from the throne of God. Water represents life – pure life, without sin. The Gematria of this verse is beautiful. It sums up the whole history of the redemption from sin and the com-

plete eradication of sin, for it uses the three basic numerals, 1, 6 and 8.

10608 = And he showed me a pure river of water of life, clear as crystal, proceeding out of the throne of God and of the Lamb. (Revelation 22:1)

The connection between water and the 3,000 years from the payment for sin to the eradication of sin, was pictured for us way back in Genesis 1. And it used the beautiful Golden Proportion – .618.

> *"And God said, Let there be a firmament in the midst of the waters, and let it divide the waters from the waters. And God made the firmament, and divided the waters which were under the firmament from the waters which were above the firmament: and it was so. And God called the firmament Heaven. And the evening and the morning were the second day."* (Genesis 1:6-8 – even the chapter and verse numbers bear the 1, the 6 and the 8)

The Gematria and the use of the Golden Proportion reveals that it was part of a magnificent plan. For the portion of the text that speaks of the dividing of the waters, bears the number 3000, and it is divided into two sections, one bearing the number 1854, and the other

bearing 1146. The relationship of these numbers is the beautful Golden Proportion.

1854 = The waters which were under the firmament

המים אשר מתחת לרקיע

1146 = The waters which were above the firmament

המים אשר מעל לרקיע

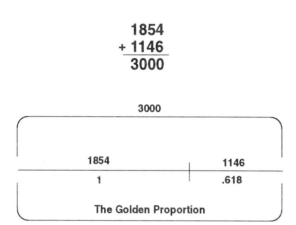

1854
+ 1146
3000

3000

1854 1146

1 .618

The Golden Proportion

The dividing of the waters above the heavens from the waters below the heavens bears the number 3000. There will be 3,000 years between the payment for the price of sin to the complete eradication of sin from mankind. At the end of the 3,000 years, the invitation will be given: *"Let him that is athirst come. And whosoever will, let him take of the water of life freely."* (Revelation 22:17)

When Jesus stood up, on that Great Eighth Day of the Feast of Tabernacles, and proclaimed *"If anyone*

thirsts, let him come," (3000) He was proclaiming the wonderful fact that 3,000 years from His offering of Himself, the water of life would be available for all – a free gift!

The time from the first festival of the Sacred Year – Passover – to the Great Eighth Day of the Feast of Tabernacles, was 186 days. Again, bearing the special numerals, 1, 6 and 8. Even the Gematria of *"The last day of the Feast of Tabernacles"* has a number value of 681, the reverse of the 186 days. In Revelation 22 this day is described as the time when the curse that was placed on the earth because of sin, will be removed. It reads: *"And there was no more curse."* It has a number value of 1860. This number has a very special relationship to the day (Passover) and the place (Golgotha) where He offered Himself as the price for sin. And it also has a special relationship to the Golden Proportion. The place of Golgotha (*Γολγοθα,* 186) had another name. It was called Calvary, *Κρανιον,* which has a number value of 301.

These two numbers relate to each other as a Golden Proportion.

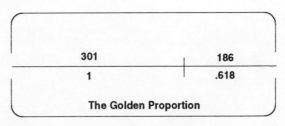

The Golden Proportion

The numerals 1, 6 and 8 and the beginning of the Great Eighth Day

186 = And there shall be no more curse, (Rev. 22:3)

186 = It is finished (Rev. 16:17)

186 = Forever (Isa. 64:4)

186 = According to His image (Gen. 5:3) (By the beginning of the Great Eighth Day man will once again be in the image of God, just as Adam was before he sinned.)

681 = The Last Day of the Feast of Tabernacles

681 = Perfect (complete)

816 = The Day of Conclusion (8th day of Feast of Tabernacles)

816 = His Dominion

861 = Eternity

861 = Very early in the morning (morning of the Great Eighth Day)

168 = In His image (Gen. 1:27) (Man will again be in His image by the beginning of the Great Eighth Day)

1680 = Christ *(Χριστου)*

10608 = And he showed me a pure river of water of life, clear as crystal, proceeding out of the throne of God and of the Lamb. (Revelation 22:1)

618 = The Lord shall be King over all the earth (Zechariah 14:9)

.618 is the Golden Proportion

186,000 mps is the speed of light (Jesus is the "light of the world.")

On April 3, A. D. 33, at 3:00 in the afternoon, as Jesus hung on the cross he cried out, *"It is finished."* These three English words are from the one Greek word, γεγονεν, which has a number value of 186. As He breathed His last breath, the moon went into eclipse. It should have been a full moon when it rose over Jerusalem that night, but it was still in eclipse for 17 minutes.

Passover is always on a full moon. The moon, in the scriptures, represents the relationship of Israel to God through the Law Covenant. It was Israel's connection with God. But that day, as Jesus died at 3:00 in the afternoon, the moon began to disappear. From that point on, Israel's connection with God would have to be through the blood of Christ. The moon played a vital role in the events of that memorable day. So let's show it as connected to the earth, and the numbers of the place on the earth where the price for sin was paid.

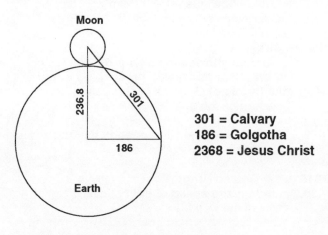

301 = Calvary
186 = Golgotha
2368 = Jesus Christ

The numbers shown are not distance, they are proportion. The exact proportion of the combined radii of earth and moon produces the numbers that you see here. The name Jesus Christ is intricately connected to the numbers 186 and 301, by both of its spellings.

2368 = Jesus Christ, *Ιησους Χριστος*
2368 = Jesus Christ, *Ιησου Χριστου*

That simple graphic on the opposite page tells the story of redemption. It tells the story that Jesus Christ shed His blood on Calvary (301), which is Golgotha (186) on the night of the eclipsed full moon, and put an end to Israel's Law Covenant, opening the way for mankind to live forever (186). And, by the way, the word "moon" in Greek is *σεληνη*, and it has a number value of 301.

Summary: The three Pilgrim Festivals are little pictures of three great ages of time.

1. Passover – The Passover Age began with the first Passover, in the spring of 1448 B.C., when Moses began to lead the Israelites out of Egyptian bondage. It progressed until its fulfillment in the spring of A.D. 33, when Jesus, the great antitypical Passover Lamb, hung on the cross of Calvary, shedding His innocent blood for the guilty blood of Adam.

2. Pentecost – The Pentecost Age began in the spring of A.D. 33, when the outpouring of the Holy Spirit came

upon the believers. It was the espousal of the bride of Christ. The age progresses through 49 x 40 years, bringing us to the spring of A.D. 1993, at which time the great antitypical Pentecost Day began. It is a 40-year day, ending in the spring of A.D. 2033.

3. Tabernacles – The seven-day Feast of Tabernacles was a little picture of Earth's Great Millennium. It begins at the end of the Pentecost Age, and progresses for a thousand years. It includes the *"Little Season"* in which Satan will be loosed from his prison and allowed a final opportunity to test man's faithfulness. Satan and all those who follow him will be destroyed forever. Then will follow the Great Eighth Day Feast – the crowning feast of the Sacred Year. It will see mankind restored to all that Adam had lost – perfection of human nature, the curse lifted from the earth, and man living in peace and in harmony with his Creator for an eternity.

> *"Behold, the tabernacle of God is with men, and he will dwell with them, and they shall be his people, and God himself shall be with them, and be their God. And God shall wipe away all tears from their eyes; and there shall be no more death, neither sorrow, nor crying, neither shall there be any more pain; for the former things are passed away."* (Revelation 21:3-4)

6

Confirmation by Time Blocks

Let me begin with a definition. The term "block" has 26 meanings in my dictionary. When speaking of "blocks" of time, I am using definition number 13: "A quantity, portion, or section taken as a unit or dealt with at one time."

It is the purpose of this book to find blocks of time that jump over the year-by-year details of chronology, and give us a larger picture. The search is for blocks that will overlap, using elements of each, that will confirm the whole. Such blocks do exist. And they provide powerful evidence for the correctness of the whole.

In the previous chapter we saw three great blocks of time, pictured by the three Pilgrim Festivals. These took us from 1448 B.C. to A.D. 3033. However, I stated previously that the date at which Adam sinned was the spring of 3968 B.C. This leaves an un-spoken-for gap of 2520 years, from 3968 B.C. to 1448 B.C. What evidence do we have that this time block did indeed exist?

First, if we painstakingly did the year-by-year chronolgy, we would find that indeed, this is the amount of time from the entrance of sin to the first Passover and the Law Covenant. But we are going to attempt to confirm this block of time by another method.

The number 2520 is a Biblical number. It exists many times in prophecy – usually called *"seven times."* In prophecy, a "time" is a period of 360 days or 360 years. It is based on the original year which existed before the Flood, which was 360 days in length. Seven of these would equal 2,520 days, or years. Even the Gematria reveals that seven times (or years) equals 2,520.

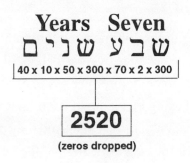

Years Seven

ש ב ע ש נ י ם

| 40 x 10 x 50 x 300 x 70 x 2 x 300 |

2520

(zeros dropped)

When computing the year-by-year chronology, the span from the entrance of sin to the first Passover does indeed add to 2,520 years. It is divided into two significant spans: first is a span of 1,656 years from the entrance of sin to the Flood, and second, a span of 864 years from the Flood to the first Passover. All three of these numbers are importantly significant in the Gematria of the Bible.

We found in the previous chapter we were able to identify the three great blocks of time that were pictured by the Pilgrim Festivals, thus each of those three were

named according to the festival involved. But what will we name the 2,520 years from the entrance of sin to the first Passover? Is this span of time specifically mentioned in the Bible, and if so, what is it called?

The Apostle Paul said it the most succinctly that we will find in the entire Bible. He said, *"Death reigned from Adam to Moses."* (Romans 5:14) He was speaking of the fact that the entrance of sin brought the death penalty; and that death reigned until the Passover Lamb was killed, and the Law Covenant was established, which offered the opportunity for life. So, let's take Paul's name for this span of time. Let's call it *"Death Reigned."*

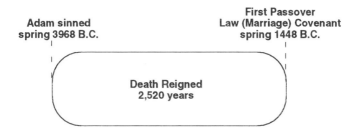

Adam sinned
spring 3968 B.C.

First Passover
Law (Marriage) Covenant
spring 1448 B.C.

Death Reigned
2,520 years

The number 2520 is used in prophecy repeatedly, usually called *"seven times"* or half that figure, stated as *"time, times, and the dividing of time,"* which would be 1,260 years. In the book of Revelation it is stated as periods of 42 months, or sometimes as 1,260 days. But aside from its use in prophecy, the number 2520 is a very unique number. It is the lowest number that is evenly divisible by all nine digits. And, although those first 2,520

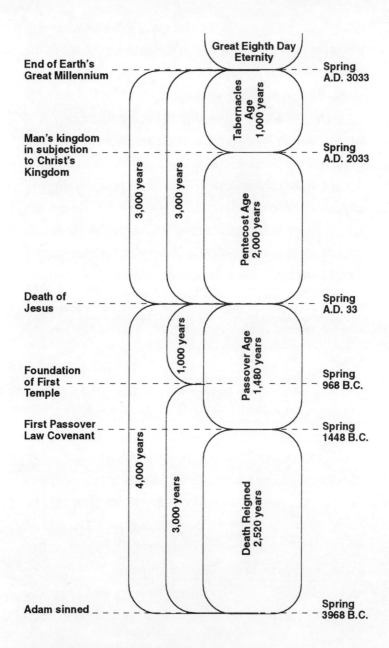

End of Earth's
Great Millennium — — — — — — — — — — — — — — — Spring
A.D. 3033

Great Eighth Day
Eternity

Tabernacles
Age
1,000 years

Man's kingdom
in subjection — — — — — — — — — — — — — — — Spring
to Christ's A.D. 2033
Kingdom

3,000 years

3,000 years

Pentecost Age
2,000 years

Death of — — — — — — — — — — — — — — — — — Spring
Jesus A.D. 33

1,000 years

Passover Age
1,480 years

Foundation
of First — — — — — — — — — — — — — — — — — Spring
Temple 968 B.C.

First Passover — — — — — — — — — — — — — — Spring
Law Covenant 1448 B.C.

4,000 years

3,000 years

Death Reigned
2,520 years

Adam sinned — — — — — — — — — — — — — — — Spring
3968 B.C.

96 Time and the Bible's Number Code

years were the years when Death Reigned, yet the very
number itself points the way to salvation and life through
the Lord Jesus Christ. Let's divide it by each of the nine
digits, and then obtain an average by dividing the total
by 9 – a simple mathematical principle.

$$2,520 \div 1 = 2,520$$
$$2,520 \div 2 = 1,260$$
$$2,520 \div 3 = 840$$
$$2,520 \div 4 = 630$$
$$2,520 \div 5 = 504$$
$$2,520 \div 6 = 420$$
$$2,520 \div 7 = 360$$
$$2,520 \div 8 = 315$$
$$2,520 \div 9 = \underline{280}$$
$$\text{Total} \quad 7,129$$

$$7,129 \div 9 = 792.1$$

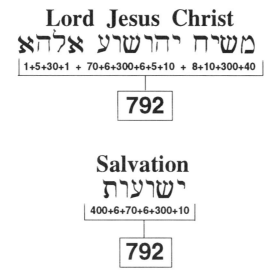

Lord Jesus Christ

משיח יהושע אלהא

| 1+5+30+1 + 70+6+300+6+5+10 + 8+10+300+40 |

792

Salvation

ישעות

| 400+6+70+6+300+10 |

792

Thus, even though there were 2,520 years during which Death Reigned, yet salvation had already been planned for man from the beginning.

The graphic on page 96 shows two 3,000-year spans, divided by a 1,000-year span, making a total of 7,000 years. The first 3,000-year span bridges the time between the sin of Adam, in the spring of 3968 B.C. to the laying of the foundation of the first Temple, by Solomon, in the fourth year of his reign. It marks an important pivotal point in the whole chronology of man. This is probably why the chronicler, who wrote the record of the kings, was led to give us the precise time measure from the Exodus from Egypt, to the laying of the foundation of the Temple. This important time-span is recorded in I Kings 6:1. It reads:

"And it came to pass in the four hundred and eightieth year after the children of Israel were come out of the land of Egypt, in the fourth year of Solomon's reign over Israel, in the month Zif, which is the second month, that he began to build the house of the Lord." (I Kings 6:1)

"In the fourth year was the foundation of the house of the Lord laid, in the month Zif." (I Kings 6:37)

Some chronologers have assumed that this text contained a copyist error, and the letter representing the number 4 (ד) should really have been a 5 (ה). They state that the little left leg of the ה was inadvertently left off, making it look like ד. The problem with that explanation is

that the Gematria was not used here in the original text, but, in fact, the names of the numbers were spelled out. And the preposition "in" is prefixed to the number, making it ordinal. The Hebrew text looks like this (read from right to left).

בשמונים שנה וארבע מאות

hundred four and year eightieth the in

Many chronologers also fail to realize that this number is ordinal. It is not 480 full years, but *in* the 480th year, which would be something between 479 full years and 480 full years. Thus, counting forward from the date of the Exodus 479 years and 1 month, produces the 2nd month (Nisan to Nisan years) in our calendar year 968 B.C., – or about our month of May. Computing the years from Nisan to Nisan, it would fall in the beginning of the year 3000 from the date when Adam sinned.

When I first saw this calculation, I was puzzled. It did not appear to fit with the date of the death of King David and the beginning of Solomon's reign. Then I went back and re-checked the Biblical record. Fantastic! How had I missed it!

Solomon had, in fact, been granted a co-regency with his father David for about 3 years. It becomes apparent when reading the historical record.

Solomon was anointed king while David was still

alive. That fact is made apparent in I Kings 1. In the 39th verse it tells of his coronation.

> *"And Zadok the priest took an horn of oil out of the tabernacle, and anointed Solomon. And they blew the trumpet; and all the people said, God save King Solomon."*

But David was still alive. The writer of the book of Chronicles fills in the details. After stating, *"So when David was old and full of days, he made Solomon his son king over Israel,"* (I Chronicles 23:1), he spends the next six chapters telling all the deeds of David between the coronation of Solomon and David's death. God had told David that he would not be permitted to build the Temple because he was a warrior king. But David collected all the materials for building the Temple. He gave to Solomon detailed plans for the construction of the Temple. All this he did before he died.

We do not know the exact month of David's death, but we are told that he reigned in Jerusalem 33 years. Immediately after David's death, Solomon began the work of laying the foundation of the Temple. It was the year 968 B.C., in the month Zif (the next month after Nisan), exactly 33$\frac{1}{2}$ years from the time when David had moved his kingdom to Jerusalem.

This important date in history is a pivotal point in

God's plan for the salvation of man. It also provides a critical time-link between the date of the first Passover and the laying of the foundation of the Temple, avoiding the necessity of a year-by-year account of the experiences of Israel in the wilderness, in occupying the promised land, in being ruled by judges, and the making of Saul as their first king.

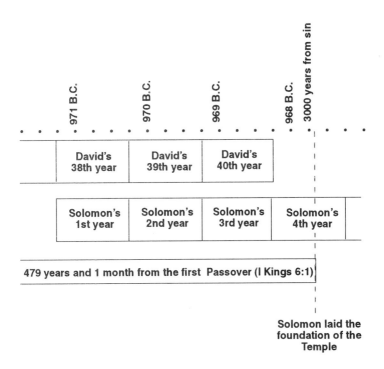

On page 96 is a simple graphic showing the relationships of the time blocks, revealing two 3,000-year periods, evenly divided by a 1,000-year period. Now I

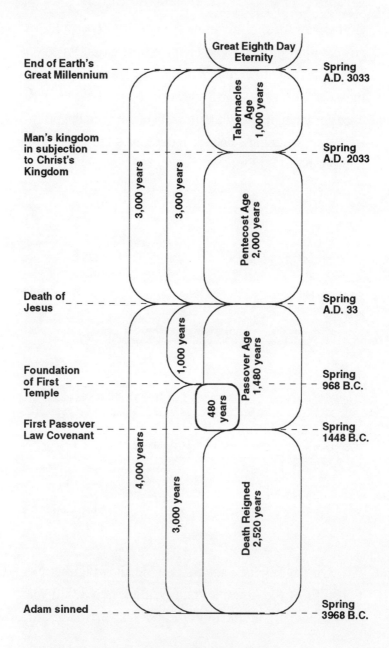

Great Eighth Day Eternity

End of Earth's Great Millennium — Spring A.D. 3033

Tabernacles Age 1,000 years

Man's kingdom in subjection to Christ's Kingdom — Spring A.D. 2033

3,000 years

3,000 years

Pentecost Age 2,000 years

Death of Jesus — Spring A.D. 33

1,000 years

Passover Age 1,480 years

Foundation of First Temple — Spring 968 B.C.

480 years

First Passover Law Covenant — Spring 1448 B.C.

4,000 years

3,000 years

Death Reigned 2,520 years

Adam sinned — Spring 3968 B.C.

102 Time and the Bible's Number Code

want to show one more detail in the first 3,000-year period. On the opposite page, note the block of 480 years between the First Passover and the establishing of the foundation of Solomon's Temple. The number 48 in Gematria is magnificent. It is the number that takes us into sin, and then takes us back out of sin again. If 48 is lost, it takes another 48 to replace it. That may sound trite, and I can hear someone saying "Of course, stupid!" But bear with me, I'm serious.

Here is a sampling of the number 48 in the Gematria of the Bible. Notice the progression from sin to perfection.

48 = to sin, לחטא, (Exodus 9:34)

480 = the life of man, נפש האדם, (Genesis 9:5) (The life of man is required because of sin.)

4800 = The coming of the Son of Man, η παρουσια του υιου του ανθρωπου, (Matthew 24:27) (Jesus paid the required price, thus restoring life.)

480 = to make perfect (or to come to perfection), תמם

480 = They shall be My people, and I will be their God, היו לי לעם ואני אהיה להם לאלהים, (Jeremiah 32:38) (This was prophesied of restored Israel, however, the principle applies to all mankind who have returned to God by the end of Earth's Great Millennium.)

The number 48 is the product of the Golden Proportion. The function of the Golden Proportion is the healing of the effects of sin and the restoring of mankind.

Golden Proportion = .618
6 x 1 x 8 = 48

4800 x .618034 = 2966.5

3,000 years
- 2,966.5 years
33.5 years

33.5 years from perfection to sin
33.5 years from sin to perfection

Thus the 480 years from the First Passover in 1448 B.C. to the foundation of Solomon's Temple in the spring of 968 B.C. becomes a very important block of time relating to the restoration from sin. It relates to, and confirms, the $33^{1}/_{2}$ -year offset of the major time blocks of the whole story of man.

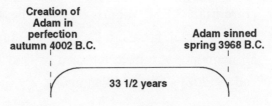

Creation of
Adam in
perfection
autumn 4002 B.C.

Adam sinned
spring 3968 B.C.

33 1/2 years

This function of the Golden Proportion, reducing 3,000 years to 2,966.5 years not only confirms the length of time that Adam was in the Garden of Eden before he sinned, but it also confirms the three major, overlapping, 3,000-year spans of time within which our whole chronology rests.

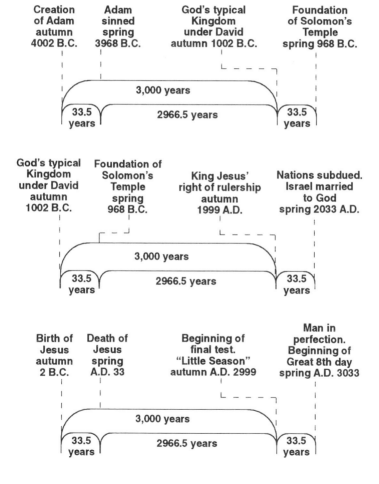

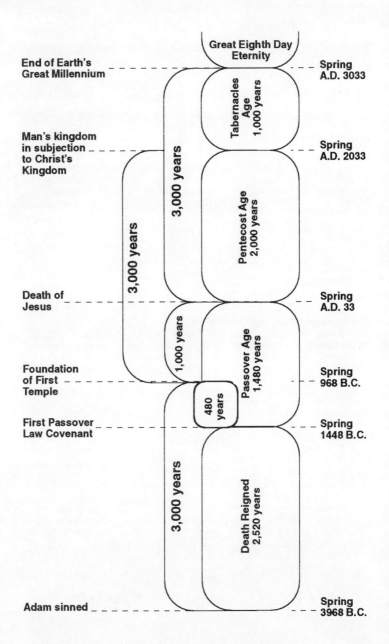

Great Eighth Day
Eternity

End of Earth's
Great Millennium — — — — — — — — — — — — — — — Spring
A.D. 3033

Tabernacles
Age
1,000 years

Man's kingdom
in subjection — — — — — — — — — — — — — — — — Spring
to Christ's
Kingdom — — — — — — — — — — — — — — — — A.D. 2033

3,000 years

Pentecost Age
2,000 years

3,000 years

Death of
Jesus — — — — — — — — — — — — — — — — — — Spring
A.D. 33

1,000 years

Passover Age
1,480 years

Foundation
of First — — — — — — — — — — — — — — — — Spring
Temple 968 B.C.

480
years

First Passover
Law Covenant — — — — — — — — — — — — — — Spring
1448 B.C.

3,000 years

Death Reigned
2,520 years

Adam sinned — — — — — — — — — — — — — — — Spring
3968 B.C.

106 Time and the Bible's Number Code

On the opposite page is a graphic showing how these three time blocks of 3,000 years each, overlap and fit the time of the three Pilgrim Festival Ages. For simplicity I have only shown them with their spring dates. Simply move each 3,000-year period back by 33.5 years, and they would appear with autumn dates.

These spring and autumn dates are used consistently in the whole chronology of man. The autumn dates have to do with rulership, beginning with the dominion given to Adam at the time of his creation, then to the time when David set up his kingdom in Jerusalem, which was God's typical kingdom, then to the time when Jesus receives the right of rulership.

The spring dates pertain to sin and the redemption from sin's penalty, death. They begin with the entrance of sin, to the foundation of the Temple – which was the meeting place between God and man. Then to the day when Jesus hung on the cross, shedding his innocent blood in place of the guilty blood of Adam. And finally to the time when sin is fully eradicated from the earth, and mankind will live in the perfection that Adam enjoyed before he sinned.

This spring and autumn pattern is consistent throughout the entire plan of God for the redemption and restoration of man, and forms the framework, into which the whole chronology of man securely fits. They are a confirmation of the time-line.

Autumn Dates – Rulership:

4002 B.C. – King Adam

"And God said, Let us make man in our image, after our likeness: and let them have dominion ... upon the earth." (Genesis 1:25)

1002 B.C. – King David (God's Typical Kingdom)

David had been anointed king over all Israel, then when he moved his kingdom to Jerusalem, it is said of him: "And David perceived that the Lord had established him king over Israel, and that he had exalted his kingdom for his people Israel's sake." (II Samuel 5:12)

2 B.C. – Jesus Born

"Behold, thou shalt conceive in thy womb, and bring forth a son, and thou shalt call his name Jesus. He shall be great, and shall be called the Son of the Highest: and the Lord God shall give unto him the throne of his father David." (Luke 1:31-32)

A.D. 1999 – King Messiah

"Of the increase of his government and peace there shall be no end, upon the throne of David, and upon his kingdom, to order it, and to establish it with judgment and with justice from henceforth even for ever." (Isaiah 9:7)

A.D. 2999 – Satan Loosed (attempts to usurp rulership)

"And when the thousand years are expired, Satan shall be loosed out of his prison, and shall go out to deceive the nations which are in the four quarters of the earth, Gog and Magog, to gather them together to battle." (Revelation 20:7-8)

Spring Dates – Sin, Redemption and Restoration

3968 B.C. – Adam sinned

"And unto Adam he said, Because thou hast hearkened unto the voice of thy wife, and hast eaten of the tree, of which I commanded thee, saying, Thou shalt not eat of it: cursed is the ground for thy sake; in sorrow shalt thou eat of it all the days of thy life; Thorns also and thistles shall it bring forth to thee; and thou shalt eat the herb of the field; in the sweat of thy face shalt thou eat bread, till thou return unto the ground; for out of it wast thou taken; for dust thou art, and unto dust shalt thou return." (Genesis 3:17-19)

968 B.C. – Foundation of the Temple

"When thy people Israel be smitten down before the enemy, because they have sinned against thee, and shall turn again to thee, and confess thy name, and pray, and make supplication unto thee in this house: (the Temple) then hear thou in heaven and forgive the sin of thy people Israel." (I Kings 8:33-34)

A.D. 33 – Jesus Died

"He is the propitiation for our sins: and not for our's only, but also for the sins of the whole world." (I John 2:2)

A.D. 2033 – National restoration of Israel as the seat of God's Kingdom

"Speak tenderly to Jerusalem, and proclaim to her that her hard service has been completed, that her sin has been paid for." (Isaiah 40:1 NIV)

A.D. 3033 – Restoration of all mankind

"As in Adam all die, even so in Christ shall all be made alive." (I Corinthians 15:22)

"Whoever is thirsty, let him come; and whoever wishes, let him take the free gift of the water of life." (Revelation 22:17 NIV)

It can easily be seen that the whole plan of God for the redemption and restoration of man is told by the Golden Proportion of 4800. It produces the number 2966.5, which, when subtracted from each 3,000-year period, leaves an interim of $33^1/_2$ years. It forms the pattern – the framework – of Gods plan for man.

Within this framework we find other examples of the use of the Golden Proportion, which serve to confirm the time-line of the story of redemption.

The life of Moses is one such example. Moses was a special child, born at a time when all male children were being killed by order of the Egyptian Pharaoh. But he was miraculously spared, for God had a mission for his life. He became the deliverer of his people from the bondage of slavery in Egypt. His life becomes an illustration of the One who would deliver all mankind from the bondage of sin and death – Jesus Christ. Jesus was also born at a time when all the male children were being killed, by order of King Herod. But His life was spared by going to Egypt.

Moses was raised in the royal courts of Egypt, and was to be the next in line for the position of Pharaoh. But he left Egypt's royal courts and went to a desert land, where he obtained a bride. Jesus, likewise, left the royal courts of heaven, and came to earth, and here he obtained a bride.

Moses delivered his people from the bondage of

slavery, and took them to a good land that had been promised to them. Likewise, Jesus, delivered His people from the bondage of sin and death, and provides for them everlasting life.

Moses said, *"The Lord thy God will raise up unto thee a Prophet from the midst of thee, of thy brethren, like unto me; unto him ye shall hearken."* (Deuteronomy 18:15) The Apostle Peter expanded on this by saying:

> *"Repent ye therefore, and be converted, that your sins may be blotted out, when the times of refreshing shall come from the presence of the Lord; and he shall send Jesus Christ, which before was preached unto you: whom the heaven must receive until the times of restitution of all things, which God hath spoken by the mouth of all his holy prophets since the world began. For Moses truly said unto the fathers, A prophet shall the Lord your God raise up unto you of your brethren, like unto me; him shall ye hear in all things whatsoever he shall say unto you."* (Acts 3:19-22)

Peter was telling us that Jesus Christ is *"that prophet"* that would be like unto Moses.

While Moses was leading the people of Israel through the desert, the people were sometimes rebellious.

As a lesson to them, God sent serpents among them, which bit many of the people, and they died. So God instructed Moses to make a copper serpent and put it up on a pole, and everyone who looked upon it would be healed of their snake-bites.

Jesus said, *"As Moses lifted up the serpent in the wilderness, even so must the Son of Man be lifted up: that whosoever believeth in him should not perish, but have eternal life."* (John 3:14-15)

The snake bite is Adamic sin, which brought death. The copper serpent is Jesus, who takes the sinners place. Those who look upon Him will be healed from the death of Adamic sin.

Thus in many respects, and from many different experiences, Moses was indeed a type of Jesus Christ. His life, and the life of Jesus, respond to the Golden Proportion in such a beautiful way that it confirms the reality of there being 4,000 years between the creation of Adam and the birth of Jesus; and there also being 4,000 years between the sin of Adam and the death of Jesus. This Golden Proportion – hailed by mathematicians as the most beautiful proportion known to man – spans the time from sin to redemption and points to the life of Moses as a type of the life of Jesus.

Moses was indeed a prophet like unto Jesus. He lived at the exact time in history that forms a Golden Proportion between Adam and Jesus.

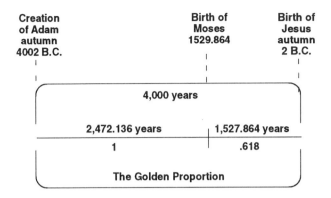

| Creation of Adam autumn 4002 B.C. | | Birth of Moses 1529.864 | Birth of Jesus autumn 2 B.C. |

4,000 years

2,472.136 years | 1,527.864 years

1 | .618

The Golden Proportion

When Moses was born his mother hid him for three months, after which she placed him in a basket and put it into the river. It was summertime because people were bathing in the river to get relief from the heat. His little basket was found by Bathia, the daughter of the Pharaoh. She desired to make this beautiful little baby her own, but needed a nurse to feed him. This is how he came to be nursed by his own mother for a brief period of time before being taken into the royal palace as the son of Bathia. Thus the point in time when his age began to count is a bit fuzzy. Very probably Bathia computed his age from the time she claimed him as her own. This would account for the apparent discrepency of a few months.

The evidence provided by this Golden Proportion is magnificent! The proportional relationship between Moses and Jesus reassures us that there are indeed 4,000

years between the creation of Adam and the birth of Jesus. And we can, with confidence, be assured that the Golden Proportion, as shown in the complete 7,000 years of man, was indeed the intention of the Creator.

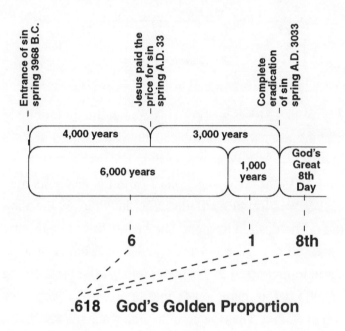

.618 God's Golden Proportion

The Golden Proportion is the very foundation principle of all creation. It is built into the six days of creation; into the six days of man's right of rulership on this earth; into the plan of God for the redemption from sin; into the size relationships of earth and moon; into the prophecies relating to Jesus and His work of redemption; into the formation of all plant and animal life; and

yes, into the formation of man himself. Our bodies are replete with the Golden Proportion. No wonder some have named it "The Divine Proportion."

Another Golden Proportion between Moses and Jesus comes between the date of Moses' death and the date of the baptism of Jesus. Moses died in the spring of 1408 B.C., just before the Israelites crossed the river Jordan to go into the promised land. The date of Jesus' baptism was in the autumn of A.D. 29, at the time when he turned 30 years old. The number of years between these two dates is 1,436.5. Multiply this by the Golden Proportion, and we obtain the number for Jesus – 888.

$$1,436.5 \times .618034 = 888$$

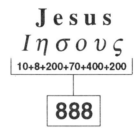

Jesus

$I \eta \sigma o \upsilon \varsigma$

| 10+8+200+70+400+200 |

888

One of the names that is prophetic of Jesus at His return is Shiloh. It was the name that Jacob used when he gave a blessing to his son Judah. Shiloh means "peacemaker" or "the one who brings rest." Before Jacob pronounced the blessings on each of his twelve sons, he

gathered them together and said, *"Gather yourselves together, that I may tell you that which shall befall you in the last days."* He was speaking prophetically of the *"last days"* of God's time-line for man.

When it came Judah's turn to receive the blessing, Jacob said, *"The sceptre shall not depart from Judah, nor a lawgiver from between his feet, until Shiloh come, and unto him shall the gathering of the people be."* (Genesis 49:10)

The prophecy is talking about rulership. The symbol of a sceptre means having the right to rule. The first king to come from the line of Judah was David. His kingdom was a type of the reign of King Messiah – the Lion of the Tribe of Judah – who was of the lineage of Judah through David. And the amazing thing is that this prophecy gives us a time-line for that rulership by both its Gematria and the Golden Proportion. It confirms the 1,000-year, 2,000-year, 3,000-year and 4,000-year periods that constitute the complete 7,000 years of man's time-line.

The blessing that Jacob placed upon the head of his son Judah reaches all the way down through time, to and including the *"last days."* On the opposite page is this prophecy as it appears in the Masoretic Text. Remember, Hebrew reads from right to left. The numbers that are found in this text confirm the time-line that we have already found to be accurate.

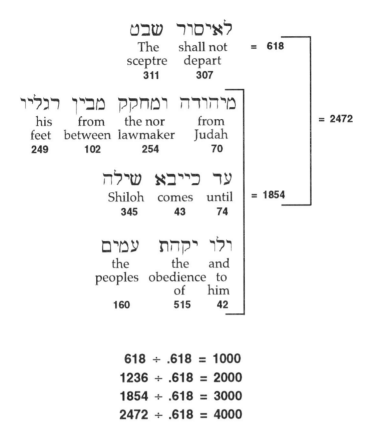

$$618 \div .618 = 1000$$
$$1236 \div .618 = 2000$$
$$1854 \div .618 = 3000$$
$$2472 \div .618 = 4000$$

The only time period not shown in this demonstration of Gematria is the 2,000-year block. It bears the number 1236. This number is remarkable in that it bears the name of Immanuel, as well as taking us back to the basic number 4800 for the very foundation of the concepts of Gematria and the Golden Proportion as they are used in the Bible. I stand in absolute awe and reverence at the evidence of the Hand of God displayed in this

simple, yet profound, demonstration of His Word and His Works.

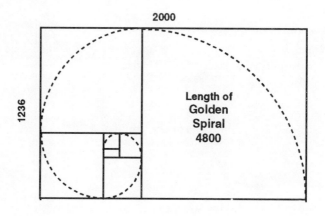

The time-line from the birth of Jesus to the expiration of man's lease of dominion is 2,000 years. Also the time-line from the death of Jesus to the complete establishment of God's Kingdom in Jerusalem, with its blessing flowing out to all nations, is 2,000 years. In Revelation 22:12, after a lengthy and magnificent vision given to John regarding the end times and the glorious Kingdom, John was given the comforting and reassuring promise: *"Behold, I come quickly, and my reward is with me."* Encoded into the Gematria of the text is the time span of 2,000 years. If we add the number equivalents from the Greek text for *"and my reward is with me,"* they will total precisely 2000.

The short side of the above Golden Rectangle gives

the name Immanuel, *"God with us,"* which in the Greek text adds to 1236. Isaiah verified this when he referred to Jesus as *"A Root out of dry ground,"* (Isaiah 53:2), which, in the Hebrew text, also adds to 1236. He was prophesying that Jesus would be the living heir to the throne of David.

The Golden Spiral that can be traced on the corners of this Golden Rectangle has a length of 4800. It is the foundation number of the Golden Proportion.

Golden Proportion = .618
6 x 1 x 8 = 48
4800 = "The coming of the Son of Man."

There are other large blocks of time that serve to confirm the chronology. One such block was given to us by the Apostle Paul. We do not know for sure if he was giving us an exact time measure, or if he simply rounded the figure for convenience. But, not knowing this, we are obligated to take his word for it. He said that there had been 430 years from the Covenant to the Law. (Galatians 3:17) He was talking about the Covenant between God and Abraham. The importance of this time-block is that it jumps over the unknown years that the Israelites were in slavery to Pharaoh, and connects the life of Abraham to the date of the giving of the Law, which was 1448 B.C.

Simple arithmatic tells us that 430 years back from 1448 B.C. would bring us to 1878 B.C. But, not so easy, is the deciding upon which event in the life of Abraham Paul called the "Covenant."

God made more than one promise to Abraham, and at different points in his life. But only one was ratified by the offering of animal sacrifice. Thus it would appear that the other promises were part of the Covenant that He made with Abraham, recorded in Genesis 15, at which time he ratified and sealed it by accepting Abraham's offering of the animals. Abraham was 85 years old.

Here, in part, was the transaction:

"And he (God) *said unto him* (Abram), *Take me a heifer of three years old, and a she goat of three years old, and a ram of three years old, and a turtledove, and a young pigeon. And he took unto him all these, and divided them in the midst, and laid each piece one against another; but the birds divided he not....And it came to pass, that, when the sun went down, and it was dark, behold a smoking furnace, and a burning lamp that passed between those pieces. In the same day the Lord made a covenant with Abram, saying, Unto thy seed have I given this land, from the river of Egypt unto the great river, the river Euphrates."* (Gen. 15:9-18)

If Paul was giving us specific time, and not round-ing the years to the nearest convenient increment, then we must consider the span of time between this event and the event of the Law Covenant given to Moses as 430 years.

The Golden Proportion confirms this to be correct. It allows us to jump over a long span of time and pin-points 1878 as the year of the Covenant with Abraham; and in the process, confirms the time all the way back to the sin of Adam.

Sometimes I think God must have had fun drawing up the blueprint for His plan for man. And surely it gives me joy when I see the evidence of such intricate plan-ning.

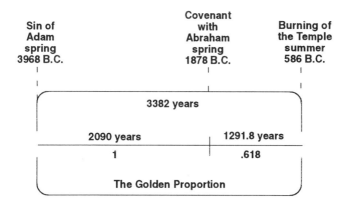

This is magnificent! It takes us from the entrance of sin to the Covenant that gives Abraham's descendants

(Israelites) a land that is to be their own. Then the second segment of the Golden Proportion takes us to the time when they were driven from that land, and taken captive to a land beyond the river Euphrates – which was outside the boundaries of the land promised to Abraham. And it proves Paul's statement of the 430 years to be correct.

This calculation ties together the whole period of time from the sin of Adam to the driving of the Israelites from their promised land. What a magnificent display of the use of the Golden Proportion, and what a beautiful confirmation of the whole time-line! For, beyond that point in history, we have an accurate written record.

We have yet another Golden Proportion that pinpoints the summer of 586 B.C. as a pre-planned date in the history of the descendants of Jacob. It is the time-span from the birth of Moses to the birth of Jesus. This span is 1527.864 years. And look where its Golden Proportion lands – precisely on August of 586 B.C.

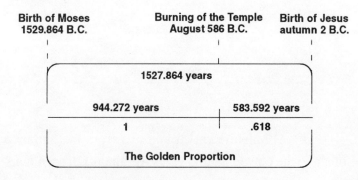

Birth of Moses 1529.864 B.C.	Burning of the Temple August 586 B.C.	Birth of Jesus autumn 2 B.C.
	1527.864 years	
944.272 years		583.592 years
1		.618
	The Golden Proportion	

These time spans, linking the sin of Adam (3968 B.C.) with the year when they were driven from Jerusalem and moved beyond the borders of their land (586 B.C.) causes me to look again at the Gematria. For the number 586 is the total of the number equivalents in the Hebrew spelling of Jerusalem.

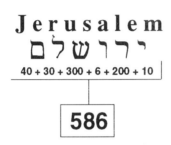

Moses was the deliverer of his people. He was the one chosen to take them to their land that had been promised to them. But God did not allow Moses to enter. Instead, God took him up to a high mountain that overlooks the land of Canaan, and there He showed Moses the whole land that Israel would possess as their homeland – as their resting place. It lay before him – from the Mediterranean Sea all the way to the River Euphrates. (Moses probably could not see that far, but that was God's description of its borders.)

The Golden Proportion of the time-span from the birth of Moses to the birth of Jesus brings us to August of the year 586 B.C. – the time when they were driven

from that land, across the Euphrates, and into Babylon.

The fact that the Gematria for Jerusalem is 586 is extremely significant, because it was in that year their national body politic came to a complete end. The land was forced to enjoy its Sabbaths – its rest. But the Bible is full of promises that it will be restored to them again, and they will eventually have rest. That restoration and that rest will come through the Lord Jesus Christ.

In the New Testament, Jerusalem is spelled in Greek, and its number equivalents add to 864.

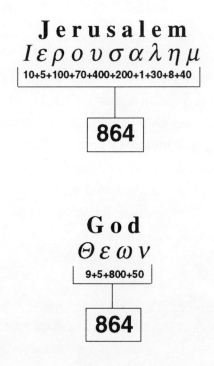

Jerusalem

Ιερουσαλημ

10+5+100+70+400+200+1+30+8+40

864

God

Θεων

9+5+800+50

864

The age during which Death Reigned is divided by
two periods of 864 years and one period of 792 years.

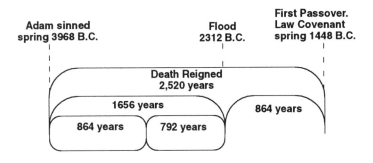

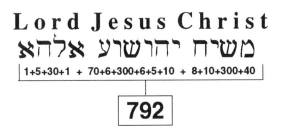

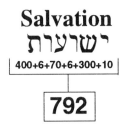

Even though it was an epoch in which Death
Reigned, yet the promise of salvation through Jesus

Christ was hidden in its interim time-spans. Full salvation for the nation of Israel will be a reality when Christ's Kingdom is fully set up in Jerusalem, and its blessings of peace and righteousness flow out to all the world – by the spring of A.D. 2033. Then will be fulfilled the prophecy of Micah 4:1-4:

> *"In the last days it shall come to pass, that the mountain* (Kingdom) *of the house of the Lord shall be established in the top of the mountains* (above all other kingdoms and nations), *and it shall be exalted above the hills; and people shall flow unto it. And many nations shall come, and say, Come, and let us go up to the mountain* (Kingdom) *of the Lord, and to the house of the God of Jacob* (Temple at Jerusalem)*; and he will teach us of his ways, and we will walk in his paths: for the law shall go forth of Zion, and the word of the Lord from Jerusalem. And he shall judge among many people, and rebuke strong nations afar off; and they shall beat their swords into plowshares, and their spears into pruninghooks; nation shall not lift up a sword against nation, neither shall they learn war any more. But they shall sit every man under his vine and under his fig tree; and none shall make them afraid:*

for the mouth of the Lord of hosts hath spoken it."

I underlined *"the word of the Lord from Jerusalem"* because it adds to 864. Yes, the new laws of righteousness, bringing peace to a troubled world, will flow out from that Kingdom which will be established in Jerusalem.

864 = the word of the Lord from Jerusalem

While the world today does its juggling act between wars, famines, pestilence and disease, polution, terrorism, slavery, and man's inhumanity to man, we can look beyond, and know that man does not have the solution; but the real solution has been planned from the beginning, by a God who never errs, and who plans for eternity.

Peace will not come to this world through the United Nations, nor through a New World Order, nor through a European Union, nor through One World Government. No! Man's lease of dominion has expired. Peace will only come through *"Him whose right it is."* Peace will only come through the Prince of Peace, and through the righteous laws of His Kingdom.

"For unto us a child is born, unto us a son is

given: and the government shall be upon his shoulder: and his name shall be called Wonderful, Counsellor, The mighty God, The everlasting Father, The Prince of Peace. Of the increase of his government and peace there shall be no end, upon the throne of David, and upon his kingdom, to order it, and to establish it with judgment and with justice from henceforth, even forever. The zeal of the Lord of hosts will perform this." (Isaiah 9:6-7)

On June 7, 1967, Jerusalem and the Temple Mount were recaptured by Israel. Although it passed without fanfare in most of the world, yet it was, in fact, the most significant event in world history since the sacking of Jerusalem and the destruction of the Temple in A.D. 70. To get a feeling for the excitement and joy of that event, read the transcript of the original recording of the Israeli Defense Forces as they were entering the Old City of Jerusalem, the Temple Mount and the Wailing Wall, that wonderful day in June:

The Temple Mount is in our hands, the Temple Mount is in our hands. All forces cease firing! The time is 10:20, the 7th of June. At this moment we are passing through the Lion's Gate. I am at present under the shadow of the gate. And again we are

emerging into the sunshine – Lion's Gate. We are in the Old City! We are in the Old City! The soldiers are standing very close to the walls. We are marching now on the Via Dolorosa, Via Dolorosa. Do we understand this? – the Old City; we are again within the Old City! Al Aksa Mosque. Al Aksa Mosque. Under the ruling of the (British) Mandate we could not enter here. One moment. Straight ahead is the *Kotel* (Wailing Wall). Hurrah! Hurrah! Hurrah! Hurrah! We don't have words to express our feelings! (Chant) *On your walls, O Jerusalem, I have set watchmen.* (Shofar begins to sound.)

Alas, they did not retain possession of the Temple Mount, and proceed to rebuild the Temple. Instead, they have been prevented from even setting foot on its holy ground. It is reminiscent of Israel's experience when they left Egypt in 1448 B.C. They could at that time, have taken possession of the Promised Land, but through fear and unbelief, they refused. Thus they were forced to wander in the wilderness for 40 years before being granted the privilege of setting foot on the holy ground that God had promised to them.

Israel did not go in and possess the holy ground after capturing it in 1967, and, just like Israel of old, they have been given 40 years of trial and testing. But after 40 years, perhaps their trial will be over. If so, then

the year 2007 should see their complete possession. It should see the completion of their deliverance from their enemies.

Some see this as a period of seven years following the time when man's lease of dominion expires, and the transfer of that right into the hands of *"Him whose right it is"* – Jesus Christ. Man's 6,000-year lease of rulership expired in the autumn of 1999. Add seven years to that date and we obtain the autumn of 2006. That year could see the battle of Armageddon and the return of Jesus, with His bride, bringing Armageddon to a sudden stop. It could see the fulfillment of the prophecy of Zechariah:

> *"Then the Lord will go out and fight against those nations, as he fights in the day of battle. On that day his feet will stand on the Mount of Olives, east of Jerusalem, and the Mount of Olives will be split in two from east to west ... Then the Lord my God will come, and all the holy ones with him ... The Lord will be King over the whole earth ... Jerusalem will be raised up and remain in its place ... it will be inhabited; never again will it be destroyed. Jerusalem will be secure."* (Zechariah 14:3-11 NIV)

To my surprise, when I took the time span between

1967 and 2033, and calculated its Golden Proportion, it produced the year 2007.

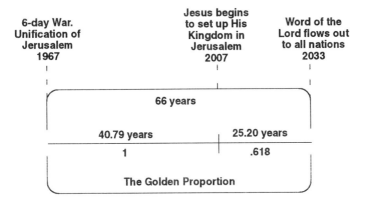

I could not help but notice this last time-span, between 2007 and 2033, it turns out to be 25.20 years. We began with the age where Death Reigned for 2,520 years, and now we end with life and blessings, beginning to reign in Israel for a period of 25.20 years. The whole experience of man from the entrance of sin to the establishment of Christ's Kingdom apparently begins and ends with this beautiful number – 2520.

Although Israel did not possess the holy ground of the Temple Mount in 1967, it may indeed have full possession by 2007. But it could possibly be telling us something more. It could be telling us that in the year 2007 Jesus will begin setting up His Kingdom in Jerusalem. A Kingdom that will first require the conversion and

acceptance of its own people, then, when that Kingdom is fully operating and bringing life and prosperity to that nation, other nations will see its life and blessings, and will desire to be a part of it.

> *"In that day you will say: 'Give thanks to the Lord, call on his name; make known among the nations what he has done, and proclaim that his name is exalted. Sing to the Lord, for he has done glorious things; let this be known to all the world. Shout aloud and sing for joy, people of Zion, for great is the Holy One of Israel among you.'"* (Isaiah 12:4-6 NIV)

7

Jubilees – a Countdown

The six "days" from Adam's sin until the blessings of life and peace flow out from Jerusalem to all the world begins and ends with the beautiful number 2520. It is no mere coincidence. The Hebrew word "forever" multiplies to 2520.

Forever

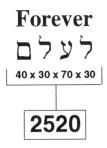

The Creation Week consisted of six days, followed by the seventh in which God rested. He set the pattern. Then He gave to man the same pattern – and it was to be *forever.*

It is one of the most basic concepts in the entire Bible. Work was to be done for six days, followed by a Sabbath of rest. The whole pattern of man's appointed time is based upon the principle of six plus one, making seven, which is followed by the eighth. As has been

shown, this succession of numbers, which is the foundation of God's pattern of time, is the Golden Proportion.

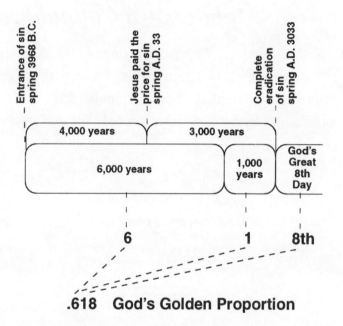

.618 God's Golden Proportion

As has been shown, the product of the numbers in the Golden Proportion is the number 48.

6 x 1 x 8 = 48

We have seen how the number 48 is basic to the whole plan of God for man, in that its Golden Proportion is 2966.5 (4800 x .618034 = 2966.5), which, when subtracted from each 3,000-year span, leaves the important 33$\frac{1}{2}$ years which overlaps each span.

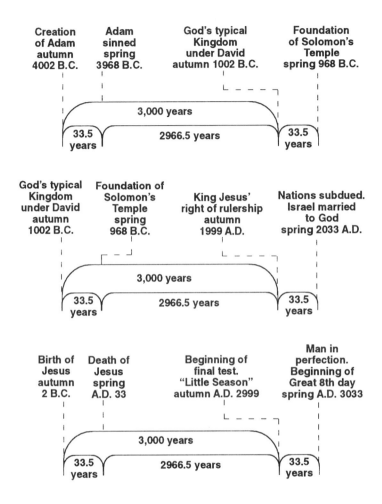

| Creation of Adam autumn 4002 B.C. | Adam sinned spring 3968 B.C. | God's typical Kingdom under David autumn 1002 B.C. | Foundation of Solomon's Temple spring 968 B.C. |

3,000 years

33.5 years | 2966.5 years | 33.5 years

| God's typical Kingdom under David autumn 1002 B.C. | Foundation of Solomon's Temple spring 968 B.C. | King Jesus' right of rulership autumn 1999 A.D. | Nations subdued. Israel married to God spring 2033 A.D. |

3,000 years

33.5 years | 2966.5 years | 33.5 years

| Birth of Jesus autumn 2 B.C. | Death of Jesus spring A.D. 33 | Beginning of final test. "Little Season" autumn A.D. 2999 | Man in perfection. Beginning of Great 8th day spring A.D. 3033 |

3,000 years

33.5 years | 2966.5 years | 33.5 years

We have also seen the importance of the number 48 in the creation, fall, and redemption of man. The means of that redemption, *"the coming of the Son of Man"* was shown to have a numeric value of 4800. The number is basic and fundamental.

Another example of the use of the number 48 is the Jubilee. Its Gematria is 48.

Jubilee

יובל

30 + 2 + 6 + 10

48

The Jubilee does, in fact, provide for us a count-down whereby we can verify the whole time-line of man. But what was the Jubilee?

Briefly stated, it is based on the six-day-work-seventh-day-rest concept. God instructed Moses to have the people work only six days, followed by a Sabbath. This not only applied to days, it applied to years. They were to count six years, and the seventh was to be a Sab-bath year. Then they were to count seven of those seven-year periods, which would be 49 years, and this was to be followed by a Jubilee, which was the 50th year. This was to be an ordinance for them *forever* (2520).

When Moses went up into the mount to receive the tables of the Law, God instructed him thus:

"And the Lord spake unto Moses, saying, Speak thou also unto the children of Israel,

saying, Verily my sabbaths ye shall keep: for it is a sign between me and you throughout your generations; that ye may know that I am the Lord that doth sanctify you. Ye shall keep the sabbath therefore; for it is holy unto you: every one that defileth it shall surely be put to death: for whosoever doeth any work therein, that soul shall be cut off from among his people. Six days may work be done; but in the seventh is the sabbath of rest, holy to the Lord: whosoever doeth any work in the sabbath day, he shall surely be put to death. Wherefore the children of Israel shall keep the sabbath, to observe the sabbath throughout their generations, for a perpetual covenant. <u>It is a sign between me and the children of Israel forever: for in six days the Lord made heaven and earth, and on the seventh day he rested, and was refreshed.</u>" (Exodus 31:13-17)

A further instruction was given to Moses concerning the counting of six years of planting and harvesting, followed by a seventh when the land would not be plowed nor reaped. Then he was instructed to count seven of these seven year periods, making 49 years, which was to be followed by a Jubilee year.

"And thou shalt number seven sabbaths of years unto thee, seven times seven years; and the space of the seven sabbaths of years shall be unto thee forty and nine years. Then thou shalt cause the trumpet of the Jubilee to sound on the tenth day of the seventh month, in the day of atonement shall ye make the trumpet sound throughout all your land. And ye shall hallow the fiftieth year, and proclaim liberty throughout all the land ... In the year of this Jubilee ye shall return every man unto his possession (meaning his inheritance of land)."* (Leviticus 25:8-13)

This law of the Jubilee could not begin until they came into the Promised Land, after they had crossed Jordan and entered Canaan. The Jubilee was to be declared on the Day of Atonement, which was in the month Tishri, therefore Jubilee years were to be from Tishri to Tishri. But they entered the land in the spring, just before Passover. The task immediately at hand upon crossing the Jordan river was to conquer Jericho. Therefore, the counting of the Jubilee cycles would not begin until Tishri – the seventh month – of that year.

The first Sabbath year, therefore, would have been Tishri 1401 B.C. to Tishri 1400 B.C. Counting seven of these Sabbath years would bring us to the first Jubilee.

From there the seven and forty-nine year cycles would look like this:

1st Sabbath	1401 B.C. - 1400 B.C.
7th Sabbath	1359 B.C. - 1358 B.C.
1st Jubilee	**1358 B.C. - 1357 B.C.**
14th Sabbath	1310 B.C. - 1309 B.C.
2nd Jubilee	**1309 B.C. - 1308 B.C.**
21st Sabbath	1261 B.C. - 1260 B.C.
3rd Jubilee	**1260 B.C. - 1259 B.C.**
28th Sabbath	1212 B.C. - 1211 B.C.
4th Jubilee	**1211 B.C. - 1210 B.C.**
35th Sabbath	1163 B.C. - 1162 B.C.
5th Jubilee	**1162 B.C. - 1161 B.C.**
42nd Sabbath	1114 B.C. - 1113 B.C.
6th Jubilee	**1113 B.C. - 1112 B.C.**
49th Sabbath	1065 B.C. - 1064 B.C.
7th Jubilee	**1064 B.C. - 1063 B.C.**
56th Sabbath	1016 B.C. - 1015 B.C.
8th Jubilee	**1015 B.C. - 1014 B.C.**
57th Sabbath	1009 B.C. - 1008 B.C.
58th Sabbath	1002 B.C. - 1001 B.C. — **David begins reign from Jerusalem**
59th Sabbath	995 B.C. - 994 B.C.
60th Sabbath	988 B.C. - 987 B.C.
61st Sabbath	981 B.C. - 980 B.C.
62nd Sabbath	974 B.C. - 973 B.C.
63rd Sabbath	967 B.C. - 966 B.C. ⎫ **Building 1st Temple**
9th Jubilee	**966 B.C. - 965 B.C.** ⎭
70th Sabbath	918 B.C. - 917 B.C.
10th Jubilee	**917 B.C. - 916 B.C.**
77th Sabbath	869 B.C. - 868 B.C.
11th Jubilee	**868 B.C. - 867 B.C.**
84th Sabbath	820 B.C. - 819 B.C.
12th Jubilee	**819 B.C. - 818 B.C.**

91st Sabbath	771 B.C. -	770 B.C.
13th Jubilee	**770 B.C. -**	**769 B.C.**
98th Sabbath	722 B.C. -	721 B.C. **Israel captive to Assyria**
14th Jubilee	**721 B.C. -**	**720 B.C.**
99th Sabbath	715 B.C. -	714 B.C.
100th Sabbath	708 B.C. -	707 B.C.
101st Sabbath	701 B.C. -	700 B.C. **14th Year of Hezekiah**
102nd Sabbath	694 B.C. -	693 B.C.
103rd Sabbath	687 B.C. -	686 B.C.
104th Sabbath	680 B.C. -	679 B.C.
105th Sabbath	673 B.C. -	672 B.C.
15th Jubilee	**672 B.C. -**	**671 B.C.**
112th Sabbath	624 B.C. -	623 B.C.
16th Jubilee	**623 B.C. -**	**622 B.C. Josiah's great Passover**
113th Sabbath	617 B.C. -	616 B.C.
114th Sabbath	610 B.C. -	609 B.C.
115th Sabbath	603 B.C. -	602 B.C.
116th Sabbath	596 B.C. -	595 B.C.
117th Sabbath	589 B.C. -	588 B.C. **Zedekiah freed all slaves.**
118th Sabbath	582 B.C. -	581 B.C.
119 Sabbath	575 B.C. -	574 B.C.
17th Jubilee	**574 B.C. -**	**573 B.C. Ezekiel's Temple vision**
126th Sabbath	526 B.C. -	525 B.C.
18th Jubilee	**525 B.C. -**	**524 B.C.**
133rd Sabbath	477 B.C. -	476 B.C.
19th Jubilee	**476 B.C. -**	**475 B.C.**
140th Sabbath	428 B.C. -	427 B.C.
20th Jubilee	**427 B.C. -**	**426 B.C.**
147th Sabbath	379 B.C. -	378 B.C.
21st Jubilee	**378 B.C. -**	**377 B.C.**
154th Sabbath	330 B.C. -	329 B.C.
22nd Jubilee	**329 B.C. -**	**328 B.C.**
161st Sabbath	281 B.C. -	280 B.C.
23rd Jubilee	**280 B.C. -**	**279 B.C.**

168th Sabbath	232 B.C. -	231 B.C.
24th Jubilee	**231 B.C. -**	**230 B.C.**
175th Sabbath	183 B.C. -	182 B.C.
25th Jubilee	**182 B.C. -**	**181 B.C.**
182nd Sabbath	134 B.C. -	133 B.C.
26th Jubilee	**133 B.C. -**	**132 B.C.**
189th Sabbath	85 B.C. -	84 B.C.
27th Jubilee	**84 B.C. -**	**83 B.C.**
196th Sabbath	36 B.C. -	35 B.C.
28th Jubilee	**35 B.C. -**	**34 B.C.**
203rd Sabbath	14 A.D. -	15 A.D.
29th Jubilee	**15 A.D. -**	**16 A.D.**
210th Sabbath	63 A.D. -	64 A.D.
30th Jubilee	**64 A.D. -**	**65 A.D.**
217th Sabbath	112 A.D. -	113 A.D.
31st Jubilee	**113 A.D. -**	**114 A.D.**
224th Sabbath	161 A.D. -	162 A.D.
32nd Jubilee	**162 A.D. -**	**163 A.D.**
231st Sabbath	210 A.D. -	211 A.D.
33rd Jubilee	**211 A.D. -**	**212 A.D.**
238th Sabbath	259 A.D. -	260 A.D.
34th Jubilee	**260 A.D. -**	**261 A.D.**
245th Sabbath	308 A.D. -	309 A.D.
35th Jubilee	**309 A.D. -**	**310 A.D.**
252nd Sabbath	357 A.D. -	358 A.D.
36th Jubilee	**358 A.D. -**	**359 A.D.**
259th Sabbath	406 A.D. -	407 A.D.
37th Jubilee	**407 A.D. -**	**408 A.D.**
266th Sabbath	455 A.D. -	456 A.D.
38th Jubilee	**456 A.D. -**	**457 A.D.**
273rd Sabbath	504 A.D. -	505 A.D.
39th Jubilee	**505 A.D. -**	**506 A.D.**
280th Sabbath	553 A.D. -	554 A.D.
40th Jubilee	**554 A.D. -**	**555 A.D.**

287th Sabbath	602 A.D. -	603 A.D.
41st Jubilee	**603 A.D. -**	**604 A.D.**
294th Sabbath	651 A.D. -	652 A.D.
42nd Jubilee	**652 A.D. -**	**653 A.D.**
301st Sabbath	700 A.D. -	701 A.D.
43rd Jubilee	**701 A.D. -**	**702 A.D.**
308th Sabbath	749 A.D. -	750 A.D.
44th Jubilee	**750 A.D. -**	**751 A.D.**
315th Sabbath	798 A.D. -	799 A.D.
45th Jubilee	**799 A.D. -**	**800 A.D.**
322nd Sabbath	847 A.D. -	848 A.D.
46th Jubilee	**848 A.D. -**	**849 A.D.**
329th Sabbath	896 A.D. -	897 A.D.
47th Jubilee	**897 A.D. -**	**898 A.D.**
336th Sabbath	945 A.D. -	946 A.D.
48th Jubilee	**946 A.D. -**	**947 A.D.**
343rd Sabbath	994 A.D. -	995 A.D.
49th Jubilee	**995 A.D. -**	**996 A.D.**
350th Sabbath	1043 A.D. -	1044 A.D.
50th Jubilee	**1044 A.D. -**	**1045 A.D.**
357th Sabbath	1092 A.D. -	1093 A.D.
51st Jubilee	**1093 A.D. -**	**1094 A.D.**
364th Sabbath	1141 A.D. -	1142 A.D.
52nd Jubilee	**1142 A.D. -**	**1143 A.D.**
371st Sabbath	1190 A.D. -	1191 A.D.
53rd Jubilee	**1191 A.D. -**	**1192 A.D.**
378th Sabbath	1239 A.D. -	1240 A.D.
54th Jubilee	**1240 A.D. -**	**1241 A.D.**
385th Sabbath	1288 A.D. -	1289 A.D.
55th Jubilee	**1289 A.D. -**	**1290 A.D.**
392nd Sabbath	1337 A.D. -	1338 A.D.
56th Jubilee	**1338 A.D. -**	**1339 A.D.**
399th Sabbath	1386 A.D. -	1387 A.D.
57th Jubilee	**1387 A.D. -**	**1388 A.D.**

406th Sabbath	1435 A.D. -	1436 A.D.
58th Jubilee	**1436 A.D. -**	**1437 A.D.**
413th Sabbath	1484 A.D. -	1485 A.D.
59th Jubilee	**1485 A.D. -**	**1486 A.D.**
420th Sabbath	1533 A.D. -	1534 A.D.
60th Jubilee	**1534 A.D. -**	**1535 A.D.**
427th Sabbath	1582 A.D. -	1583 A.D.
61st Jubilee	**1583 A.D. -**	**1584 A.D.**
434th Sabbath	1631 A.D. -	1632 A.D.
62nd Jubilee	**1632 A.D. -**	**1633 A.D.**
441st Sabbath	1680 A.D. -	1681 A.D.
63rd Jubilee	**1681 A.D. -**	**1682 A.D.**
448th Sabbath	1729 A.D. -	1730 A.D.
64th Jubilee	**1730 A.D. -**	**1731 A.D.**
455th Sabbath	1778 A.D. -	1779 A.D.
65th Jubilee	**1779 A.D. -**	**1780 A.D.**
462nd Sabbath	1827 A.D. -	1828 A.D.
66th Jubilee	**1828 A.D. -**	**1829 A.D.**
469th Sabbath	1876 A.D. -	1877 A.D.
67th Jubilee	**1877 A.D. -**	**1878 A.D.**
476th Sabbath	1925 A.D. -	1926 A.D.
68th Jubilee	**1926 A.D. -**	**1927 A.D.**
483rd Sabbath	1974 A.D. -	1975 A.D.
69th Jubilee	**1975 A.D. -**	**1976 A.D.**
484th Sabbath	1981 A.D. -	1982 A.D.
485th Sabbath	1988 A.D. -	1989 A.D.
486th Sabbath	1995 A.D. -	1996 A.D.
487th Sabbath	2002 A.D. -	2003 A.D.
488th Sabbath	2009 A.D. -	2010 A.D.
489th Sabbath	2016 A.D. -	2017 A.D.
490th Sabbath	2023 A.D. -	2024 A.D.
70th Jubilee	**2024 A.D. -**	**2025 A.D.**

Now, granted, five pages of nothing but sterile numbers is downright boring. But I had a reason, and an exciting one. If this countdown from Israel's entrance into the Promised Land to the present time will synchronize with the previously suggested chronology of man's experiences during that time-span, then we have a positive confirmation of its correctness. And this is exactly what we have!

First we find that the very year in which David was anointed King over all Israel, and the season of the year in which he set up his kingdom (God's typical Kingdom) in Jerusalem, is the beginning of the 58th Sabbath Year – Tishri 1002 B.C. to Tishri 1001 B.C. The Sabbath and Jubilee Years were for the *land,* that it might rest from cultivation and planting. This move of the seat of government from Hebron to Jerusalem was in a year that they were not occupied with plowing and planting.

Likewise we find the time during which Solomon was building the Temple was also a time when the people were not plowing and planting. In fact, at that time they enjoyed two years in which they were not occupied with this chore – allowing them time in which to do the work on the Temple.

We also find that the year in which the northern kingdom of Israel was taken captive to Assyria, 722 B.C.-721 B.C., was a Sabbath Year followed by a Jubilee Year.

But a very important synchronization can be made

with the 101st Sabbath Year and the 14th year of king Hezekiah. Of that year we have a very interesting Biblical record.

> *"This will be a sign unto you, O Hezekiah: This year you will eat what grows by itself, and the second year what springs from that, but in the third year sow and reap, plant vineyards and eat their fruit. Once more a remnant of the house of Judah will take root below and bear fruit above."* (II Kings 19:29 NIV)

Hezekiah was fearful for the kingdom of Judah, as well as for his own life. Sennacherib of Assyria had already overthrown and occupied all the surrounding countries, and now he was coming after the little nation of Judah. So Hezekiah had gone to God and asked for a sign that he and the nation would be spared. The sign that God gave was the Sabbath Year. It was to be an illustration of the fact that even though the ground had not been plowed nor planted, yet a small yield would still be obtained from it. Likewise, God would permit a small remnant of the nation to remain, and they would again grow and flourish.

The year was 701 B.C. to 700 B.C. If we count from the entrance into Canaan, we find that this would be the

101st Sabbath Year. Thus the scriptural record verifies that the count is accurate, as well as verifying that the chronology of the kings of Judah is also accurate.

The next link in verifying the time-line is the year of Josiah's great Passover. According to the chronology of the kings of Judah, this would have been in the year 623 B.C. to 622 B.C. (Tishri to Tishri). And, according to the Sabbath and Jubilee count-down, it would have been the year of the 16th Jubilee. We can reason that the fact of it being a Jubilee year influenced Josiah to plan the great Passover festival, and we might be correct in doing so. However, there is a more positive link to be found here.

The Talmud states that Josiah's great Passover was held during the 16th Jubilee Year. It appears that the Talmud is correct. It appears that our count-down is correct, and it appears that our chronology of the kings of Judah is correct. If any one of these were incorrect, then this very special synchronization would not exist.

Let's go down in time a few years and find a scriptural record that definitely sounds like it must have been a Sabbath Year.

The little nation of Judah was under siege by Nebuchadnezzar of Babylon. His army had surrounded Jerusalem but had not yet breached the walls. It was the year 589 B.C. to 588 B.C. King Zedekiah panicked. He knew that he had not been faithful to God, nor to his

own people; and now that the fear of certain death confronted him, he decided to do something drastic to possibly save his own neck. Since it was a Sabbath year, he made the decree that all slaves should be set free. It was a nice gesture, however, the people were not willing, and proceeded to take all their slaves back again. This angered God, and He told Jeremiah to give Zedekiah this message:

> *"I made a covenant with your forefathers when I brought them out of the land of Egypt, out of the land of slavery. I said 'Every seventh year each of you must free any fellow Hebrew who has sold himself to you. After he has served you six years, you must let him go free.' Your fathers, however, did not listen to me or pay attention to me. Recently you repented and did what is right in my sight: each of you proclaimed freedom to his countrymen. You even made a covenant before me in the house that bears my Name. But now you have turned around and profaned my name; each of you has taken back the male and female slaves you had set free to go where they wished. You have forced them to become your slaves again."*
> (Jeremiah 34:12-16 NIV)

As a result of this violation of the covenant, God allowed Nebuchadnezzar's army to come into Jerusalem and destroy the city and the Temple.

Thus we have a scriptural record of a Sabbath Year. It was 589B.C. to 588 B.C. It harmonizes perfectly with our count-down and with the chronology of the kings of Judah.

Most of the people living in the nation of Judah were taken captive to Babylon.

According to the chronology of the kings of Judah, and their following captivity in Babylon, we find that it was in the year 574 B.C. to 573 B.C., that Ezekiel, a captive in Babylon, had a glorious vision of a Temple that would be built again. The dating of this is specifically mentioned in the book of Ezekiel.

> *"In the twenty-fifth year of our exile, at the beginning of the year, on the tenth of the month, in the fourteenth year after the fall of the city – on that very day the hand of the Lord was upon me and he took me there. In visions of God he took me to the land of Israel and set me on a very high mountain."* (Ezekiel 40:1-2 NIV)

According to our count-down, this was the 17th Jubilee Year. The Talmud states that Ezekiel received the Temple vision in the 17th Jubilee Year.

Our count-down thus appears to be accurate, and is in complete harmony with the chronology presented thus far in this book.

If all of this is correct – and it appears to be so – indulge me for a moment, and let me project into the future. I realize that this is going way out on a limb; and you, my valued reader, hold the saw. And if not, then time itself will either make or break it.

We have observed the evidence that brought us to the autumn of A.D. 1999 as the time when the right of earth's rulership changed from man's hands to Messiah's. We have observed that very probably the time when Jesus, with His bride, come to put an end to Armageddon and to turn back Israel's enemies is in the autumn of 2006. The interim is seven years. Amazingly, a Sabbath Year falls precisely in the middle of this short span.

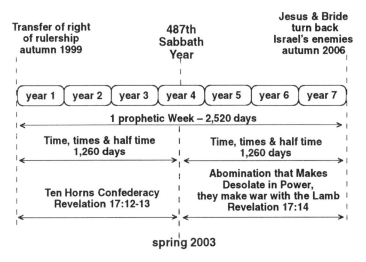

"The ten horns which thou sawest are ten kings, which have received no kingdom as yet; but receive power as kings one hour (the same hour) *with the beast. These have one mind, and shall give their power and strength unto the beast. These shall make war with the Lamb, and the Lamb shall overcome them: for he is Lord of lords, and King of kings: <u>and they that are with him are called, and chosen, and faithful.</u>"* (Revelation 17:12 - 14)

Those who are with the Lamb are His called, chosen, and faithful followers, who become His bride.

According to Revelation 19, the marriage takes place *before* He comes with His bride to turn back Israel's enemies. If He comes with His bride at the end of the 2,520 days, then sometime prior to that He must come *for* His bride and take her to the wedding chamber – the place that He went away to prepare for her.

"In my Father's house are many rooms … I am going there to prepare a place for you. And if I go and prepare a place for you, I will come back and take you to be with me, that you also may be where I am." (John 14:2-3 NIV)

This narrows down a short window of time in which the fulfillment of this promise will take place.

Some may look at that long, boring list of the Sabbaths and Jubilees and say, "But that's not the way Israel counts Sabbaths now." And you would be right.

The Encyclopedia Judaica tells us that when the exiles returned to Jerusalem from their captivity in Babylon, they began to count a new Sabbath cycle. This new cycle has been in use for well over 2,500 years. And we have historical records of events that happened on Sabbath years, which confirm the counting as accurate. This new cycle started to count in the year 535 B.C. when the altar was built and then the foundation of the second Temple was laid. Thus it is two years different from the dates of the original cycle.

But, we might ask, does God honor this apparent man-made cycle? Is it a valid keeping of the Sabbaths and Jubilees? My instinctive answer would be "No." But my instincts don't always prove to be right. As I was working with this second cycle, to attempt to find exactly where we are today, I noticed something absolutely fantastic!

I counted the seven-year cycles, and the 49-year cycles, bringing us to the current time. It placed the year Tishri 2000-Tishri 2001 as a Sabbath Year – also making Tishri 2007-Tishri 2008 as a Sabbath Year. But along the way, the cycle landed on a year that really caused me to sit up and take notice. As I did the math, I realized that the year Tishri 1917-Tishri 1918 was the 50th Jubi-

lee Year since the beginning of this second cycle.

1917 was a milestone year for the descendants of Jacob who were scattered over the face of the earth. World War I was ending, and major re-organization of policies and politics was spreading across Europe. A seasoned statesman and philosopher came to the spotlight in England, who made a proposal that changed the world – at least for the descendants of Jacob. His name was James Arthur Balfour. He was, at that time, the British foreign secretary. On November 2, 1917 he wrote the following:

```
Dear Lord Rothschild,
   I have much pleasure in conveying to
you, on behalf of His Majesty's Govern-
ment, the following declaration of
sympathy with Jewish Zionist aspirations
which has been submitted to and approved
by the Cabinet.
   His Majesty's Government view with
favour the establishment in Palestine of
a national home for the Jewish people
and will use their best endeavours to
facilitate the achievement of this
object, it being clearly understood that
nothing shall be done which may preju-
dice the civil and religious rights of
existing non-Jewish communities in
Palestine, or the rights and political
status enjoyed by Jews in any other
country.
   I should be grateful if you would
bring this declaration to the knowledge
of the Zionist Federation.
                        Yours,
                        (Signed) James Arthur Balfour
```

That famous letter was written near the beginning of Israel's 50th Jubilee Year since their return to Jerusalem from Babylonian captivity. It paved the way for the descendants of Jacob to return once again to their ancient homeland, and there be established as a nation.

Thirty one years later, the State of Israel was born, on May 14, 1948. But there was a major obstacle to their occupying their ancient capital of Jerusalem. Not until the Six-Day War in June of 1967 did they once again, after so many long years, occupy their beloved Jerusalem.

The Balfour Declaration was signed in November of 1917, at the beginning of Israel's 50th Jubilee Year, and just 50 years later, in the summer of 1967, (another Jubilee Year), they were now in the place of their ancient capital – the place where God's typical Kingdom, under David, had been located.

As I punched out the numbers on my calculator I stood in absolute awe of the precision with which God has designed His time. The Golden Proportion of that 50-year span lands precisely on May 14, 1948 – *to the day!*

These three milestone dates, November 2, 1917, May 14, 1948, and June 7, 1967 reveal the obvious fact that the hand of God was at work in the destiny of this people, whom He had cast off, but to whom He had made promises for their return to their land, and to Him.

The first date, November 2, 1917, is in a Jubilee Year. June 7, 1967 is in a Jubilee Year. And that beautiful Golden Proportion that says *"speak to the heart of Jerusalem"* (Isaiah 40:1) points directly to May 14, 1948 – the day they became a nation again. Praise God for His magnificent plan and the precision of His time!

The heart of Jerusalem

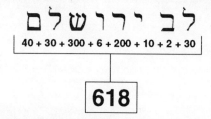

Golden Proportion = .618

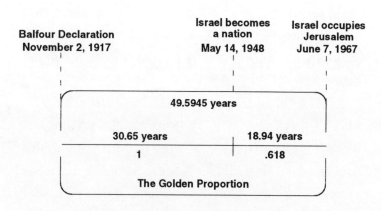

Over and over again, the use of the Golden Proportion has proven to be indeed the "Divine Proportion," as it is sometimes called by mathematicians. It tells us that the events of Israel's rebirth are not simply the result of random time and random events. It is part of a glorious plan. And its fulfillment in our own lifetimes is magnificent.

This demonstration of the precision of the Golden Proportion gives us an insight into the validity of the second Jubilee cycle – the one that the exiles, who returned from Babylon, set up in place of the original cycle. It allows us to use this cycle with confidence in the process of confirming the time-line from the building of the second Temple to today.

Many Sabbath Years have been recorded in history since that time. And because the length of time between them is always divisible by 7, it gives us confidence in their authenticity. A Sabbath Year was mentioned in I Maccabees 16:14, which computes to the year 135 B.C. Josephus tells of another in 37 B.C.. In fact, years that have been identified as Sabbath Years in history are 331 B.C.; 163 B.C.; 135 B.C.; 37 B.C.; A.D. 41, 55, 69, 132, 433, and 440. These dates give the year in which the larger part was during the Tishri to Tishri Sabbath Year. This is made clear in the Encyclopedia Judaica, where Sabbath Years are listed for the 20th century, and they are in perfect harmony with the years mentioned in his-

tory, all of which have intervals evenly divisible by 7. Thus the chronology from the time of the building of the second Temple to the present is confirmed by the Jubilees.

Having established this time-span, let's look just a little closer at its significance. Perhaps, using the patterns that we have observed in God's time, we can look from the known to the unkown, and confirm a future date that is exciting!

8

"Seven Times"

One of the exciting things about a study of the Bible is its recording of time. Sometimes these eras of time are spelled out very plainly, and sometimes they are a bit more subtle.

Of the more subtle variety is the use of a period called "Seven Times." How much time is meant by these code words?

A "Time" in prophetic use is one year of 360 days. It can be used prophetically as 360 days, or sometimes 360 years – a day for a year. Thus seven of these days, or years, would be 7 x 360 = 2,520. As previously mentioned, the number 2,520 is the lowest number that is evenly divisible by each of the nine digits, therefore it is basic to prophetic time. Even the Gematria brings this basic number to our attention:

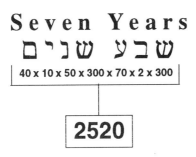

Seven Years
שבע שנים
40 x 10 x 50 x 300 x 70 x 2 x 300

2520

First, let's go all the way back to Leviticus 26 and look at a promise that God made to Moses. This promise had two contingencies: one was faithfulness, the other unfaithfulness.

For faithfulness, God promised:

> *"If you follow my decrees and are careful to obey my commands, I will send you rain in its season, and the ground will yield its crops and the trees of the field their fruit. Your threshing will continue until grape harvest and the grape harvest will continue until planting, and you will eat all the food you want and live in safety in your land. I will grant peace on the land, and you will lie down and no one will make you afraid."*

However, for unfaithfulness the promise was:

> *"I will bring upon you sudden terror, wasting diseases and fever that will destroy your sight and drain away your life. You will plant seed in vain, because your enemies will eat it. I will set my face against you so that you will be defeated by your enemies; those who hate you will rule over you ... If after all this you will not listen to me, I will punish you for your sins* **seven times.**"

This is only a small portion of the text. In reality, it promises a "seven times" punishment four times. If "seven times" is a period of 2,520 years, does this mean that she will receive punishment for her sins during four different periods of 2,520 years? Or perhaps these four eras overlap, giving us an undefined period of time – or all four times it is mentioned it is talking about the same 2,520-year period. How do we know?

Let's look at history. Was Israel faithful? No, she was cast off in A.D. 33 when Jesus said *"Your house is left unto you desolate."* Therefore we must expect there to be one or more time-spans of 2,520 years, during which Israel has been punished.

These instructions to Moses also mentioned that if they did not obey, God would scatter them among all the nations of the world, allowing the land to keep all of its pre-determined number of Sabbaths, or rest years.

In search for the 2,520 years, let's try some possibilities. Counting back 2,520 years from the autumn of 1917 brings us to the autumn of 604 B.C. It was a turbulent time for the little nation of Judah. A few months previously (in 605 B.C.) Daniel and his companions had been captured and taken to Babylon by Nebuchadnezzar. At that time, Nebuchadnezzar's father, Nabopolassar, died, and Nebuchadnezzar hurried back to Babylon to occupy the royal throne.

It was in the second year of his occupying the royal

throne of Babylon that he had a dream of an image made of several different metals, and he watched, as a small stone was cut out of a mountain, and it struck the image on its feet and the whole thing fell, and was ground to such small pieces that the wind simply blew it away. The year was 604 B.C., exactly 2,520 years prior to the Balfour Declaration in 1917.

It was the beginning of the end for the little nation of Judah. During that year, God gave Jeremiah a prophecy concerning Nebuchadnezzar's siege of Egypt, in which Judah would be vitally involved (Jeremiah 46). But God comforted Jeremiah by telling him that ultimately his people would be saved and would again inhabit their land and live in peace and safety.

> *"Do not fear, O Jacob my servant; do not be dismayed, O Israel. I will surely save you out of a distant place, your descendants from the land of their exile. Jacob will again have peace and security, and no one will make him afraid. Do not fear, O Jacob my servant, for I am with you ... Though I completely destroy all the nations among which I scatter you, I will not completely destroy you. I will discipline you but only with justice; I will not let you go entirely unpunished."* (Jeremiah 46:27-28)

This may seem to be a strange statement for God to make to Jeremiah at that time, for the scattering among all nations was in the distant future from 604 B.C. By the very words of the prophecy, it is evident that God was telling about Israel's final regathering at which time He would protect them and cause them to dwell in the land in peace and safety.

And when did Israel obtain the official release to go back and to establish themselves as a nation? It was in the autumn of 1917, by the promise of the Balfour Declaration.

The interim between 604 B.C. and A.D. 1917 is 2,520 years. It is one of the "seven times" that God promised would be the result of their unfaithfulness.

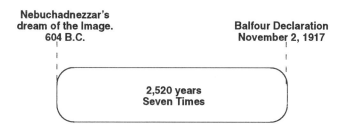

Sixteen years later, Nebuchadnezzar's army came back, and laid siege to Jerusalem. Zedekiah, king of Judah, panicked. He knew that this meant his certain death, so, realizing that it was a Sabbath Year, he told the people to free all of their slaves, hoping that it would

appease God and he would be spared. The year was 588 B.C.

Coming down through time 2,520 years brings us to the year 1933. It was the year that Adoph Hitler rose to power in Germany. For those who lived through that era during which he ruled as dictator, we remember the pictures that we saw of the concentration camps, filled with starving Jews; and we remember the stories of the death chambers, where six million prisoners were murdered – not for any crime that they had committed, but simply for being a descendant of Jacob.

Was this part of the "seven times" that was promised for disobedience? Perhaps!

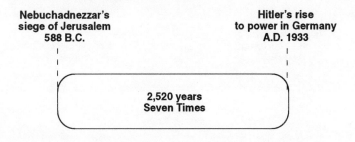

Coming down through time fifteen more years we find another landmark. Ezekiel the prophet was residing in Babylon, having been taken there as a captive by Nebuchadnezzar. Israel's beautiful Temple had been burned and the city of Jerusalem plundered, and Ezekiel mourned for the loss of Israel's "connection" with God.

But God encouraged him, and gave him a vision of another, even more glorious Temple that would someday be built. The year was 573 B.C. It was a Jubilee Year, but of course they could not observe the Jubilee because they were not in the land. The land was at rest, enjoying a God-enforced Sabbath.

Counting 2,520 years from 573 B.C. brings us to A.D. 1948 – the year in which Israel once again became a nation.

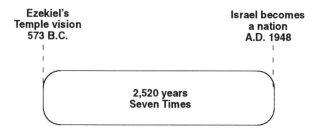

This covers three of the four 2,520-year periods promised to Moses for Israel's unfaithfulness. But what about the fourth one? For that we must project into the future.

Coming down through time 58 more years, we find the captives in Babylon having been liberated by Cyrus, king of Persia, when he overthrew Babylon; the exiles had been allowed to return and had begun to build the Temple again.

Following the reign of Cyrus, Cambyses became

the ruler of Persia. After a brief seven years, Cambyses took his own life. He was followed on the throne by Darius I.

Darius encouraged the returned exiles to finish the Temple that they had begun in the days of Cyrus. They finally completed it and dedicated it on the 3rd of the month Adar, in the year 515 B. C. The returned exiles finally had a Temple again – their meeting place with God. Counting 2,520 years from that date brings us to the year A.D. 2006. It is the year that has previously been observed to be the time when Jesus would come, with His bride, to turn back Israel's enemies and to put an end to Armageddon.

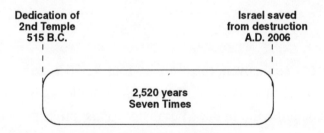

"Seven Times" was promised to come upon Israel four times. We observe that four periods of 2,520 years have been identified, all of which have to do with their demise and their ultimate salvation.

Salvation comes through a Saviour. That Saviour

was promised by a prophecy that God gave to Isaiah, in which He said that the Saviour's name would be called Immanuel.

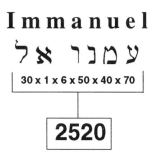

The total time of the overlap of these four 2,520-year spans is 89 years.

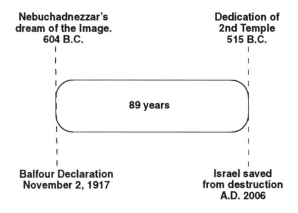

There is one more 89-year span which was preparatory to Israel's restoration and her regaining of the city

of Jerusalem. It begins with an event that was indeed a turning point in the history of her long dispersion among the countries of the world.

In the summer of 1878 the nations of central Europe sent representatives to the Berlin Congress of Nations. Queen Victoria, of England, sent her beloved Prime Minister, Benjamin Desraeli, known also as Lord Beaconsfield, to the Congress, with a proposal regarding Jewish emancipation. It opened the way for the First Aliyah to begin a settlement in Palestine. In 1878 the first settlers came, and their village later became known as Petah Tikvah, which means "Door of Hope."

This event was truly the beginning of the restoration of the children of Jacob to their ancient homeland. It was the beginning of the fulfillment of all the promises that God had made to them. It was the beginning of their finality – their return to God which would ultimately result in their re-marriage to Him. This ultimate finality is reflected in the name of this first little village – Petah Tikvah – for its Gematria adds to 999. Nines always have reference to finality and fulfillment. And the triplet of nines raises the concept to its highest order. Yes, the years since that small beginning in the summer of 1878 have seen the growing fulfillment of God's promises to restore to Jacob his inheritance.

In the summer of 1967, they finally gained access to their beloved city, Jerusalem. The interim between

these two events is exactly 89 years.

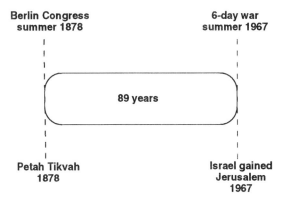

This entire span of time, from 1878 (the First Aliyah) to 2032 (the re-marriage) is a period of 154 years. Within that 154-year span, the Golden Proportion has identified *every one* of the major milestones along the way to Israel's sovereignty as a nation and her ultimate complete return to God.

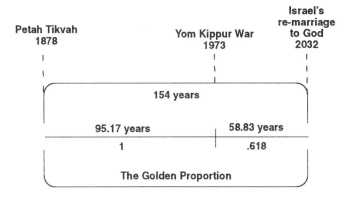

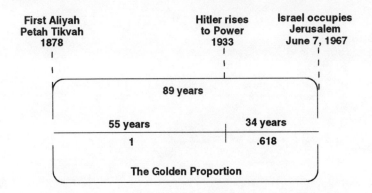

First Aliyah
Petah Tikvah
1878

Hitler rises
to Power
1933

Israel occupies
Jerusalem
June 7, 1967

89 years

55 years | 34 years

1 | .618

The Golden Proportion

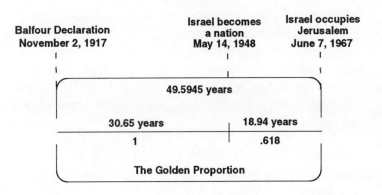

Balfour Declaration
November 2, 1917

Israel becomes
a nation
May 14, 1948

Israel occupies
Jerusalem
June 7, 1967

49.5945 years

30.65 years | 18.94 years

1 | .618

The Golden Proportion

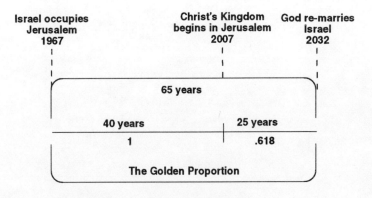

Israel occupies
Jerusalem
1967

Christ's Kingdom
begins in Jerusalem
2007

God re-marries
Israel
2032

65 years

40 years | 25 years

1 | .618

The Golden Proportion

There are nine major waymarks along the path to Israel's restoration, and every one of them interacts with the Golden Proportion. The number 9, as used in the Gematria of the Bible, represents fulfillment and finality. Those nine are:

1878 - The First Aliyah, Petah Tikvah, the Door of Hope
1917 - Balfour Declaration
1933 - Hitler's rise to power, killing of 6 million Jews
1948 - Israel becomes a nation
1967 - 6-day War, Israel gains Jerusalem
1973 - Yom Kippur War
2006 - Jesus comes to turn back Israel's Enemies
2007 - Jesus begins his Kingdom from Jerusalem
2032 - God's re-marriage to Israel

The fact that each of these dates responds to the Golden Proportion is absolutely fantastic! Isaiah used the Golden Proportion when describing the time when Israel would be healed. He said:

> *"The light of the sun shall be sevenfold, as the light of seven days, in the day that the Lord bindeth up the breach of his people, and healeth the stroke of their wound."* (Isaiah 30:26)

"The breach of his people" began with the demise of God's Typical Kingdom and their being taken captive to other nations. It continued to the divorce in A.D. 33

as Jesus hung on the cross. It reached its height when the Roman army came into Jerusalem, destroyed the Temple and dispersed its citizens throughout all the nations of the world.

The healing of the breach began with the First Aliyah which became their Door of Hope, through which their restoration could be acquired. It continues until Israel is completely restored, and re-married to God.

The remarkable way in which each of these processes responds to the Golden Proportion is in keeping with the promise: *"He will heal the breach of his people."*

The breach of His people

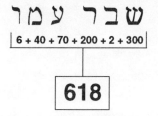

שבר עמו

6 + 40 + 70 + 200 + 2 + 300

618

The Golden Proportion is .618

The heart of Jerusalem

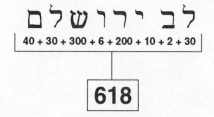

לב ירושלם

40 + 30 + 300 + 6 + 200 + 10 + 2 + 30

618

"Comfort, O comfort My people, says your God. Speak lovingly to the heart of Jerusalem, yea, cry to her that her warfare is done, that her iniquity is pardoned; for she has received of Jehovah's hand double for all her sins." (Isaiah 40:1 KJV II)

Israel's punishment was to be for *"seven times."* As we have seen, this is a period of 2,520 years. It was spoken four times. If we were to multiply 2,520 by 4, we would obtain 10080. This number is the Gematria for the phrase *"On the Seventh Day."* And indeed it is on the great Seventh Day from the creation of Adam that Israel's healing is complete, and her warfare is done.

The number 10080 is also the number of miles in the combined diameters of earth and its moon. In the symbology of the Bible, the moon represents the Law Covenant – the Marriage Covenant – between God and Israel. Thus this number 10080 is symbolic of the re-union of Israel with God in a new Marriage Covenant.

As has been shown, the number 2520 is also the Gematria for Immanuel – the One who was promised, the One who was planned from the beginning. It is He who will accomplish this reconciliation between Israel and God.

This wonderful number – this basic number which is evenly divisible by each of the nine digits, is the link

that holds holds together the entire plan of God for man. It brought us from the sin of Adam to the typical Passover – a span of 2,520 years. And now we see how it links together the ending of the national polity of Israel and Judah with the restoration of that national body politic – the State of Israel. But more importantly, the number 2,520 links the ending of God's typical Kingdom with the antitypical Kingdom – the Kingdom of Jesus Christ. He sits on the throne of David.

> *"Of the increase of his government and peace there shall be no end, upon the throne of David, and upon his kingdom, to order it, and to establish it with judgment and with justice from henceforth even forever."* (Isaiah 9:7)

9

Putting it All Together

In all the foregoing chapters, we have been looking at little pieces – little pieces of a grand and glorious time-plan that brings man from his creation in perfection, through the experience with sin and its ravages, all the way to his restoration. And, at best, we see only little pieces.

It has been observed, however, that all of God's plans for man have been according to a definite and fore-ordained time schedule. A plan that He obviously had from the beginning. And, it has also been observed, that the time-line of man has conformed to definite rules of mathematics and Gematria – they are patterns of time and numbers. It must also be acknowledged that what we have seen in this book merely scratches the surface of a subject so vast that it will take an eternity to realize its full beauty. Truly, all we have seen is little pieces.

Putting those little pieces all together into one graphic that would fit on a page in this book is something like trying to squeeze the universe into a tea cup. Can't be done! But the following illustration is a feeble attempt. It will, perhaps, show relationships and a continuity of time that will take us through the entire 7,000 years of man's history and future.

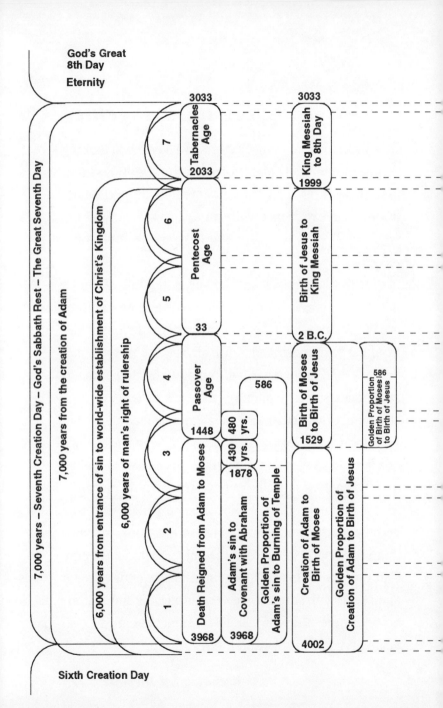

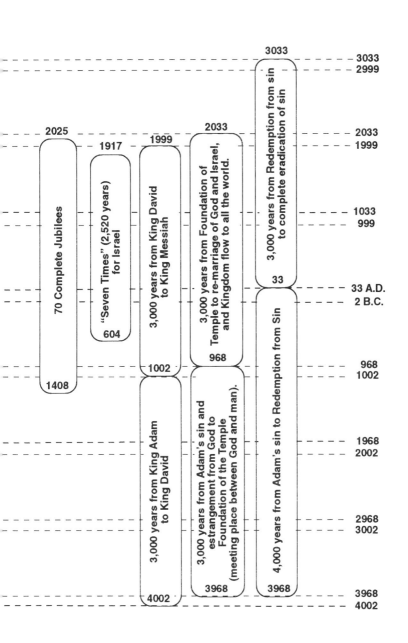

It appears, from the time-line and from prophecy, that the Kingdom of God will be established in Jerusalem, and will grow to fill the whole world. It was illustrated by the dream of Nebuchadnezzar in which he saw a great image of gold, silver, bronze, iron and clay. And as he watched, he saw a little stone cut out of the mountain without hands. It was hurled down and struck the image on its toes. After demolishing the entire image and all its component parts, the stone then began to grow until it filled the whole world.

That stone is Jesus Christ, and the Kingdom that He will establish in Jerusalem. It grows and fills the entire earth with its blessings of life, peace and prosperity. It's not just a day-dream. It's a promise!

> *"In the time of those kings, the God of heaven will set up a kingdom that will never be destroyed, nor will it be left to another people. It will crush all those kingdoms and bring them to an end, but it will itself endure forever. This is the meaning of the vision of the rock cut out of a mountain, but not by human hands — a rock that broke the iron, the bronze, the clay, the silver and the gold to pieces. The great God has shown the king what will take place in the future. The dream is true and the interpretation is trustworthy."* (Daniel 1:44-45 NIV)

The Kingdom that will shortly be set up in Jerusalem will not be for Israel alone. It begins with their salvation – saving them from their Gentile and Semetic enemies. And it continues to their conversion and return to God – and finally to their re-marriage to God.

> *"No longer will they call you Deserted, or name your land Desolate. But you will be called Hepzibah* (My delight is in her), *and your land Beulah* (married); *for the Lord will take delight in you, and your land will be married ... as a bridegroom rejoices over his bride, so will your God rejoice over you. I have posted watchmen on your walls, O Jerusalem; they will never be silent day or night. You who call on the Lord give yourselves no rest, and give him no rest till he establishes Jerusalem and makes her **the praise of the earth.**"* (Isaiah 62:4-7 NIV)

Jeremiah was given a prophecy that may be hard for some to believe, but it is indeed from God.

> *"Return, faithless people, declares the Lord, for I am your husband. I will choose you ... and bring you to Zion ... At that time they will call Jerusalem The Throne of the Lord, and*

all nations will gather in Jerusalem to honor
the name of the Lord." (Jeremiah 3:14-17 NIV)

Yes, this Kingdom of peace will be not for Israel
alone, but it will flow out from there to engulf the whole
world. It is the Kingdom for which Jesus taught us to
pray *"Thy Kingdom Come. Thy will be done on earth as
it is in heaven."* Jesus certainly would not have taught
us to pray for such a Kingdom if it were not to be a real-
ity.

> *"He will rule from sea to sea and from the
> River to the ends of the earth. The desert tribes
> will bow before him and his enemies will lick
> the dust. The kings of Tarshish and of distant
> shores will bring tribute to him ... all kings
> will bow down to him and all nations will serve
> him ... All nations will be blessed through him,
> and they will call him blessed ... may the whole
> earth be filled with his glory."* (Psalm 72:8-19
> NIV)

Appendix *I*

The Dates of Jesus' Birth and Death

There have been many dates suggested for the birth of Jesus. Some have suggested 4 B.C.; others have insisted that He was born in 6 B.C. And still others move it up to 1 B.C. It is all in the general time frame, but for our purposes, it would be good if we could pin-point it more accurately.

One of the early Christian Fathers, Tertullian, born about A.D. 160, stated that Augustus began to rule 41 years before the birth of Jesus, and died 15 years later. *(Tert. adv. Judaeos c.8)* The date of Augustus' death is recorded as August 19, A.D. 14. This would place the birth of Jesus at 2 B.C. (One year is subtracted because there is no zero year between B.C. and A.D.)

In the same chapter, Tertullian stated that Jesus was born 28 years after the death of Cleopatra. Her death is recorded in history as occurring in 30 B.C.; again placing the birth of Jesus in 2 B.C.

Irenaeus, who was born about a hundred years after Jesus, stated *(iii 25)* that "Our Lord was born about the forty-first year of the reign of Augustus." Since Augustus began his rulership in the autumn of 43 B.C.,

it would place the birth of Jesus in the autumn of 2 B.C.

Eusebius (c. 264-340 A.D.), who was termed the Father of Church History, wrote: "It was the forty-second year of the reign of Augustus and the twenty-eighth from the subjugation of Egypt on the death of Antony and Cleopatra," *(Eccles. Hist. i5)*. The 42nd year of Augustus began in the autumn of 2 B.C. and ended in the autumn of 1 B.C. The subjugation of Egypt and its incorporation into the Roman Empire occurred in the autumn of 30 B.C.; therefore, the 28th year from that time extended from the autumn of 3 B.C. to the autumn of 2 B.C. Hence the only possible date for the birth of Jesus that would meet both of these requirements would be the autumn of 2 B.C.

The historian, Josephus, referred to a lunar eclipse that occurred shortly before the death of Herod. Since we know that Herod was alive when Jesus was born, can we place Herod's death by the date of the eclipse?

It has been suggested by some that the lunar eclipse of March 13, 4 B.C. would place the death of Herod prior to that date. However, lunar eclipses are common, often happening two or three times in a single year. Since Josephus, referring to the burning of Matthias by Herod, said, "And on that very night there was an eclipse of the moon," it must have been a noticeable eclipse, and at an hour when people were awake to see it. To find the correct eclipse to which Jospehus referred, it would have to

comply with the following requirements:

1. An eclipse not less than two months but less than six months prior to a Passover.

2. Be visible in the early part of the night at Jerusalem.

3. Be of sufficient magnitude to be noticeable.

An eclipse that complies perfectly with these requirements occurred on the evening of December 29, 1 B.C., almost exactly three months before Passover. It was an eclipse of about 7 digits, thus more than half of the orb was obscured. The moon was already in eclipse when it rose over Jerusalem that night, and continued for about two hours, so that even children would have been able to see it before being put to bed.

Since Herod died shortly after the burning of Matthias, but two months before the Passover, his death would have occurred some time in January of 1 B.C. An ancient Jewish scroll, the *Magillah Ta'anith*, written during the lifetime of Jesus, gives the day and month of Herod's death as the 1st of Shebat. This would have been January 14 on the Julian calendar.

Information given in the Bible concerning the time of the conception of John the Baptist furnishes another method of determining the date of Jesus' birth. Elizabeth, the cousin of Mary, was the wife of Zacharias, the

priest. Zacharias was of the course of Abijah. Luke 1:8-13 states that while Zacharias *"executed the priest's office before God in the order of his course"* he was given the message that Elizabeth would have a son and that they should name him John. In verses 23 and 24 it is recorded, *"And it came to pass that as soon as the days of his ministration were accomplished, he departed to his own house."*

The priests were divided into 24 classes (I Chronicles 24:7-19), and each class officiated in the temple for one week. The courses of the priests changed duty with the change of the week, *i.e.,* from the end of the Sabbath at sundown until the next Sabbath. Both the Talmud and the historian, Josephus, state that the temple was destroyed by Titus on August 5, A.D. 70, and that the first course of priests had just taken office. The previous evening was the Sabbath. The course of Abijah was the 8th course, thus, figuring backward we are able to determine that Zacharias ended his course and came off duty on July 13, 3 B.C., and returned home to Elizabeth. The conception of John occurred that weekend (13th-14th) and the birth of John would take place 280 days later, namely, April 19th-20th of 2 B.C., precisely at the Passover of that year.

Elizabeth hid herself five months, and at the beginning of her 6th month the angel Gabriel appeared to Mary, telling her of Elizabeth's condition. At the same time

Gabriel told Mary that she, too, would conceive and bear a son who would be called Jesus. Upon hearing this, Mary went *"with haste"* from Nazareth to Ein Karim to visit Elizabeth, who was then in the first week of her 6th month. The time was the 4th week of December, 3 B.C. The 23rd of December of that year, by the Julian calendar was precisely the winter solstice. If this were the date of the conception of Jesus, 280 days later would place the date of His birth at September 29, 2 B.C., *i.e.,* the first day of Tishri, the day of the Feast of Trumpets – the Hebrew New Year, Rosh Hashanah.

Luke 3:1 states that John the Baptist began his ministry in the 15th year of Tiberius Caesar. According to the Law of Moses, an Israelite was considered of age for the ministry at 30 (Numbers 4:3). Augustus had died on August 19, A.D. 14; thus that year became the accession year of Tiberius, even though he had been involved in and associated with the Roman rulership before Augustus died. If John the Baptist had been born April 19-20, 2 B.C., his 30th birthday would be April 19-20, A.D. 29, or the 15th year of Tiberius. Thus the 2 B.C. date for the birth of John is confirmed by the Biblical record. John was 5 $1/3$ months older than Jesus, making the birth of Jesus to be near the end of September of that same year.

We know that Jesus was 30 years old at the time of His baptism (Luke 3:23). Thus if He had been born in the autumn of 2 B.C., the baptism would have been in

the autumn of A.D. 29. We have a scriptural testimony that four Passovers occurred during His ministry (John 2:13; 5:1; 6:4; 13:1). The counting of 4 Passovers would bring Him to the spring of A.D. 33. The day of His death was on that 4th Passover, the 14th of Nisan. It was the day of full moon, and it was Friday, April 3, of the year A.D. 33. At 3:00 in the afternoon, as He was dying on the cross, the moon eclipsed. It was still in eclipse for 17 minutes after it rose over Jerusalem that night.

Although some have attempted to date the year of the crucifixion at other years, and the day of the week as other than Friday, we have a document written at the time, which clears away all other suggested dates. This document resides today in the British Museum in London. It is a letter that Governor Pontius Pilate wrote to the Roman Emporer, in an attempt to explain the reason for having crucified Jesus. At the end of the letter he dates the writing: *"The 5th of the calends of April."* The word *Calends* has reference to the first of a month, thus it appears to mean the fifth day of the beginning of April. Thus this letter was written two days **after** the crucifixion.

Those who attempt to date the crucifixion in A.D. 32 must confront the fact that Nisan 14 of that year was a Monday (April 13) – eight days **after** Pilate wrote the letter. Pilate's letter, telling Caesar why the crucifixion which he had just ordered and executed, was necessary,

dated April 5, cannot possibly fit the supposed April 13 date for the crucifixion. It will only fit the April 3 date in the year A.D. 33.

The angel Gabriel (the same one who brought the announcement to Mary that she would bear the Messiah), gave Daniel a prophetic time-line to the time when Messiah would come. He said:

> *"Know and understand that from the issuing of a decree to restore and rebuild Jerusalem until Messiah the Prince there will be seven weeks and sixty-two weeks ... then after sixty-two weeks the Messiah will be cut off ..."*
> (Daniel 9:25-26)

The fulfillment of this counting of time is historically precise, when computed by prophetic time. For a concise explanation of this I will quote from the New American Standard Bible, The New Open Bible Study Edition, page 942:

> The vision of the sixty-nine weeks in 9:25, 26 pinpoints the coming of Messiah. The decree of 9:25 took place on March 4, 444 B.C. (Nehemiah 2:1:8). The sixty-nine weeks of seven years equals 483 years, or 173,880 days (using 360-day prophetic years). This leads to March 29, A.D. 33, the date of the Triumphal Entry. This is checked by noting

that 444 B.C. to A.D. 33 is 476 years, and 476 times 365.24219 days per year equals 173,855 days. Adding twenty-five for the difference between March 4 and March 29 gives 173,880 days.

This footnote in the New Open Bible pin-points the day precisely. Note that it counts from 444 B.C. rather than 445 B.C. – the year when most chronologers begin the count-down. This was not done to cut and make it fit. It was done because of a little item from history that is overlooked by some chronologers. They count from the year of Xerxes' death, which was in 465 B.C., adding 20 years. But 465 B.C. was not the first year of Artaxerxes.

Xerxes was killed while he was asleep in his bed by a man named Artabanus. Knowing that Xerxes' oldest son and heir to the throne was Darius, Artabanus proceeded to kill him also. This left Artaxerxes as the heir to the throne of Persia. But Artaxerxes was just a young teenager.

So Artaxerxes was set up under the pretense of being the king, but Artabanus was really in power. This arrangement lasted seven months. Artabanus became unhappy with Artaxerxes, and decided to kill him. But in the scuffle, Artaxerxes succeeded in killing Artabanus.

Soon after this event, another son of Xerxes, Hystaspis, who had been on a journey, heard of the death

of the king, and returned to claim his right to the throne. Artaxerxes proceeded to kill him also. This left only Artaxerxes as the heir to the throne of Persia. But the year was no longer 465, it was now 464. Thus his 20th year, the year of the decree to rebuild the wall of Jerusalem, was indeed 444 B.C., just as is stated in the New American Standard Bible.

Counting Daniel's prophetic time from this date brings us precisely to Nisan of A.D. 33., and the day of His triumphal entry into Jerusalem, four days before His crucifixion.

69 weeks x 7 = 483 solar years
483 years x 360 = 173,880 days
173,880 days ÷ 365.24219 = 476 prophetic years
444 B.C. to A.D. 33 = 476 years

Some claim that the timing of this prophecy does not come to any specific date and therefore attempt to re-work the interim times of the seven weeks and the sixty-two. However, the above demonstration shows the simplicity of the calculation, using prophetic time.

God's time is precise. Exactly 476 years elapsed from the decree of Artaxerxes, given to Nehemiah to return to Jerusalem and rebuild its wall, to the day when Jesus rode into Jerusalem, as they proclaimed him King. It was a prophecy – and must be computed by prophetic

time.

It is for this reason that the remaining "week" must also be computed by prophetic time. But that subject is beyond the scope of this Appendix.

Because of all the above evidence, I believe it can be stated with confidence that Jesus was born on September 29, 2 B.C. and died on April 3, A.D. 33, according to the Julian calendar, which was then in use.

Appendix *II*

Chronology

As with all chronologies of man, we begin with Adam. However, it must be remembered that there was a time lapse between his creation and the day he sinned. It has been shown that this time between his creation and his sin was a period of 33½ years. Therefore, as we begin the countdown from Adam, we begin with the date of his sin – 3968 B.C.

Because we are more familiar with B.C. dating rather than counting forward from Adam, our count-down will be exactly that – we will be subtracting years from 3968 B.C. Our accustomed use of time is on the basis of January-to-January years. However, the counting of Sabbath and Jubilee years are Tishri-to-Tishri. Kings sometimes used Nisan-to-Nisan as their regnal years, and sometimes Tishri-to-Tishri. These differences could, and sometimes do, make a difference of one year in the resulting date. Differences can also be found in the dating from the births of father to son, because the days and months are not given – only the year. Thus in the genealogies there could also be small differences in the resulting total time.

I feel, however, that the recording of the genealo-

gies between Adam's sin and the Flood can be added
with no discrepencies as to the day and month, because
the total, 1,656 years, is definitely one of the sacred num-
bers of the Bible's Number Code. It fits the pattern of
numbers that tell the story of salvation. Those 1,656 years
are obtained from the Genesis record thus:

<div style="text-align:center">

Adam to Seth 130
to Enos 105
to Cainan 90
to Mahalaleel 70
to Jared 65
to Enoch 162
to Methuselah 65
to Lamech 187
to Noah 182
to the Flood 600
1,656 years

</div>

When we get to the account of the Flood, in Gen-
esis 7, it appears to be a bit ambiguous. Verse 6 begins
with the summary statement that *"Noah was 600 years
old when the flood water was upon the earth."*

This summary statement is followed by more
detailed information: Verses 11-13 *"In the 600th year of
Noah's life, in the 2nd month, the 17th day of the month,
the same day were all the fountains of the great deep
broken up, and the windows of heaven were opened up
... In the selfsame day entered Noah ..."* The 600th year

would be when he was 599 years old.

Genesis 8:13-16 says that in the 601st year, 2nd month, 27th day of the month, Noah came out of the Ark. He would still be 600 years old in his 601st year. Thus this statement that Noah was 600 when the waters were upon the earth is correct, for Noah did, in fact, turn 600 while he was in the Ark. It would have been 2312 B.C., (3968 - 1656 = 2312).

Noah's grandson, Arphaxad was born two years after the Flood began. The Flood began while Noah was still 599 years old. This would make Noah 601 years old when Arphaxad was born. The genealogies from Arphaxad, as listed in Genesis are as follows:

2312 B.C. to Arphaxad 1
to Salah 35
to Eber 30
to Peleg 34
to Reu 30
to Serug 32
to Nahor 30
to Terah 29
to Abraham 130
351 years

When God ratified the covenant with Abraham (Genesis 15), Abraham still had no children. Yet the Covenant made provision for Abraham's heirs. His wife was old, and past her childbearing years, so she gave

her handmaid to Abraham in hopes that an heir would be conceived.

> *"...after Abram had been living in Canaan ten years, Sarai his wife took her Egyptian maid-servant Hagar and gave her to her husband to be his wife. He slept with Hagar, and she conceived."* (Genesis 16:3-4 NIV)

This event probably took place very soon after God had ratified the Covenant with Abraham. The only dating we have here is the statement that Abraham had been living in Canaan for ten years. However, when the child was born, it is stated that Abraham was 86 years old. (Genesis 16:16)

If the child was conceived after Abraham had been living in Canaan for ten years, then we must go back and find how old he was when he began living in Canaan.

Again, it is not precisely clear. Genesis 12:4 says that *"Abram was seventy-five years old when he set out from Haran."* We don't know how long it took him to reach Canaan from Haran, or how long it took him to settle in Canaan. If he were still seventy-five years old when he settled in Canaan, then the conception of Hagar's child and the time of the Covenant would have been when Abraham was 85 years old.

In chapter 6 we dealt with time blocks. It became

apparent that the age which we called "Death Reigned from Adam to Moses" was a period of 2,520 years. This was calculated backward from the date of the Law Covenant that God gave to Moses in the spring that the Israelites left Egypt. It was 1448 B.C. We have seen that the first 1,656 years of that 2,520-year span took us to the date of the Flood, leaving 864 more years to 1448 B.C.

The number 864 is very prominent in the Gematria of the Bible. It is one of the sacred numbers. It is used often in reference to God and His plan for the salvation and restoration of man. And, because other numbers in the time blocks are also sacred numbers, it lends strength to the suggestion that 864 is indeed the proper number of years between the Flood and the Law Covenant.

However, when we actually count the time sequences that are available to us in the Biblical record, it appears to be 866 years. It is entirely possible that within the span of 351 years between the Flood and the birth of Abraham, the two extra years could occur. This is because the Genesis record does not state the exact time, to the month and day, between the births of father and son – it only counts it in whole years, which could increase the apparent time.

The next link in the chronology as given in the Bible is between the giving of the Law, in 1448 B.C. and the laying of the foundation of Solomon's Temple in 968 B.C. – a span of 479 years and 2 months, bringing it into

the 480th year. This span is given to us in I Kings 6:1, and was discussed at length in chapter 6.

Following this is the span during which the kings reigned in both Judah and Israel. Synchronizing the reigns of these kings is a very difficult task, for there were co-regencies, interregna, accession years, and differing regnal years, which are not specifically recorded in the Old Testament record, but can be observed by careful comparison of the text.

Accounting for these irregularities, the space of time that the kings ruled in Israel and Judah can be brought into complete harmony with the records of other nations that existed at the same time, including the cuneiform tablets and stelae, as well as the famed Assyrian Eponym Canon. It can be brought into harmony with the solar and lunar eclipses which have been recorded; and it can also be brought into syncronization with the Jubilee cycle. With all of these "cross-checks" we can say with confidence that the period of time between the setting up of David's kingdom in Jerusalem, in 1002 B.C., to the destruction of Jerusalem by Nebuchadnezzar in 586 B.C. is indeed 416 years.

The Babylonian Chronicle gives us an accurate record and dating of events leading up to the destruction of Jerusalem.

Persian records give an accurate account of the dating of their kings, including events relating to the people

of Israel, all the way to their defeat by Alexander the Great in 330 B.C. These records are also in complete harmony with the known solar and lunar eclipses, which cannot be moved nor altered.

With all of these facts available I submit a timeline from Adam to Jesus.

Event	B.C. Date	Cumulative Totals	
Creation of Adam	4002	0	
Sin of Adam	3968	34	0
Seth born	3838	164	130
Noah born	2912	1090	1056
Flood	2312	1690	1656
Covenant with Abraham	1878	2124	2090
Exodus and Law Covenant	1448	2554	2520
David's Kingdom in Jerusalem	1002	3000	2966
Foundation of first Temple	968	3034	3000
Jerusalem & Temple destroyed	586	3416	3382
Ezekiel's Temple Vision	573	3429	3395
Foundation of second Temple	534	3468	3434
Dedication of second Temple	515	3487	3453
Artaxerxes I begins reign	464	3538	3504
Decree to rebuild Jerusalem	444	3558	3524
Jesus born	2	4000	3966
Jesus crucified	33	4034	4000

Counting forward two thousand years from the birth of Jesus in the autumn of 2 B.C. brings us to the autumn of A.D. 1999, thus ending 6,000 years since the creation of Adam.

Counting forward three thousand years from the crucifixion of Jesus in the spring of A.D. 33 brings us to the

spring of A.D. 3033, bringing to an end 7,000 years from the sin of Adam. This 7,000 years is the "seventh day" in which God rested from his work of creation.

The Great Eighth Day begins! Hallelujah!

Appendix *III*

The Book of Jubilees

The *Book of Jubilees* is a document said to have been written during the first century A.D., probably before the destruction of the Temple in A.D. 70. Its author is unknown. Its original text was written in Hebrew, and has since been translated into other languages, including Greek, Ethiopic, German, and English.

This work is a haggadic commentary on certain portions of Genesis and some parts of Exodus. Scholars suggest that it has an anti-Christian flavor, and harmonizes with the Jewish orthodoxy of Jesus' day.

The leading feature of the book is its chronological system of division of all ancient history into Jubilees of forty nine years. For this reason, it might appear to be a very convenient and powerful tool in the hands of a chronologer.

These chronological leaps in time, however, are often found to be at variance with the Hebrew text of Genesis and Exodus, but often in agreement with the Septuagint and Samaritan texts. These deviations are thought to be the work of translators, rather than the work of the original author; however, that is only an opinion.

So, why am I calling attention to this ancient docu-

ment? Does it have any relevance to the subject of this book?

Primarily one.

In the *Book of Jubilees*, chapter 3:14, it is stated that sin entered seven years after the creation of Adam. For this reason, some chronologers and students of prophecy feel that there were indeed only seven years between the creation of Adam and the sin of Adam.

How much confidence can we place in this suggestion by this unknown ancient author?

One way of answering that question is to examine the record of his work. If it is consistent with the Genesis record, and consistent with its own mathematics, then we might have confidence in its accuracy, or at least give it due consideration.

Let's examine some of the evidence. The Book of Jubilees, chapter 4:28 states that Adam died in the 19th Jubilee from his sin. This is in harmony with Genesis 4:32, therefore this comparison gives the author credit for accuracy.

However in the same chapter, (v. 32) he states that "In the fifty-fifth Jubilee, Noah took to himself a wife ... in the fifth week and the third year thereof she bore him Shem." We have a problem! This computes to about 2,676 years, while the Genesis account allows for about 1,557 years from Adam's sin to the birth of Shem. It begins to shatter our confidence in this document.

Yet, in the very next chapter (5:20) he states that: "Noah made an ark in every thing as he had commanded him in the twenty-seventh Jubilee, in the fifth week, in the fifth year. And he entered on the sixth year thereof, in the second month, in the new moon of the second month; until the seventeenth thereof he entered and all that were brought to him into the ark, and the Lord locked it from without, on the seventeenth, at eve."

Again, we have a problem. This computes to about 1,313 years to the day Noah entered the ark. If the author is counting from the sin of Adam, he is about 343 years short of the time given in Genesis.

The years to the birth of Shem were greatly increased, and the years to the entrance into the ark were greatly decreased.

Skipping to the last chapter in the Book of Jubilees (50:3) it states that there were 50 Jubilees of 49 years each between the sin of Adam and the crossing of the Jordan under the leadership of Joshua. This, of course, is inconsistent with what was stated in chapter 4 that there were fifty-five Jubilees to the time of Noah. The crossing of the Jordan was, in fact, more than 900 years after the Flood.

With this evidence of inaccuracy, it causes me to lose confidence in the statement of chapter 3:14 that there were seven years between the creation of Adam and his sin. The author is obviously making a play on the con-

cept of seven-year periods, and so supplied a seven-year time span between these two events. What he did not know at the point in time when this was written, is the legal transaction of the Ransom. Therefore he did not see the need for Jesus to be the exact equivalent of Adam.

Adam lived 33.5 years in perfection, and then sinned.

Jesus lived 33.5 years in perfection, and then paid the price for the sin of Adam.

It was a legal transaction from every aspect, displaying the perfect justice of God. This is why Paul said, *"As in Adam all die, even so in Christ shall all be made alive."*

Additional evidence from the Bible's Number Code, Stonehenge, and the Great Pyramid

The Bible's Number Code reveals an amazing end-time confirmation of our faith in the redemptive power of the blood of Jesus Christ. The story of the Scarlet Thread is woven through the pages of time. This remarkable story has been revealed to us through the Word written, the Word in number, the Word in the cosmos, and the Word in stone. Evidence found in the measurement and construction of Stonehenge and the Great Pyramid confirm the beautiful story of the Scarlet Thread.

Adventures Unlimited, Inc., P.O. Box 74, Kempton, IL 60946
Tel: 815-253-6390 FAX: 815-253-6300
email: auphg @ frontiernet.net
www.adventuresunlimitedpress.com

More about the Number Code of the Bible!

*Discover more about the
Author of Creation
and His time-line for the blessing of man!*

Using the Number Code, it is found that the parable of the Good Samaritan is, in fact, a time prophecy, telling the time of Jesus' return. His miracles of healing and of turning water into wine have been encoded with evidence of the time and the work of the beginning of earth's great Millennium. The Number Code takes us on a journey from Bethlehem to Golgotha, and into the Kingdom of Jesus Christ.

Adventures Unlimited, Inc., P.O. Box 74, Kempton, IL 60946
Tel: 815-253-6390 FAX: 815-253-6300
email: auphg @ frontiernet.net
www.adventuresunlimitedpress.com

Books by Bonnie Gaunt

THE STONES AND THE SCARLET THREAD
$14.95

THE BIBLE'S AWESOME NUMBER CODE
$14.95

THE COMING OF JESUS
The Real Message of the Bible Codes!
$14.95

JESUS CHRIST
The Number of His Name
$12.95

BEGINNINGS
The Sacred Design
$14.95

STONEHENGE AND THE GREAT PYRAMID
Window on the Universe
$12.95

THE MAGNIFICENT NUMBERS
of the Great Pyramid and Stonehenge
$9.95

All of the above books explore the exciting science of
Gematria, the Number Code of the Bible.

One Adventure Place
P.O. Box 74
Kempton, Illinois 60946
United States of America
Tel.: 815-253-6390 • Fax: 815-253-6300
Email: auphq@frontiernet.net
http://www.wexclub.com/aup

ORDERING INSTRUCTIONS

Remit by USD$ Check, Money Order or Credit Card

Visa, Master Card, Discover & AmEx Accepted

Prices May Change Without Notice

10% Discount for 3 or more Items

SHIPPING CHARGES

United States

Postal Book Rate { $2.50 First Item
50¢ Each Additional Item

Priority Mail { $3.50 First Item
$2.00 Each Additional Item

UPS { $5.00 First Item
$1.50 Each Additional Item

NOTE: UPS Delivery Available to Mainland USA Only

Canada

Postal Book Rate { $3.00 First Item
$1.00 Each Additional Item

Postal Air Mail { $5.00 First Item
$2.00 Each Additional Item

Personal Checks or Bank Drafts MUST BE

USD$ and Drawn on a US Bank

Canadian Postal Money Orders OK

Payment MUST BE USD$

All Other Countries

Surface Delivery { $6.00 First Item
$2.00 Each Additional Item

Postal Air Mail { $12.00 First Item
$8.00 Each Additional Item

Payment MUST BE USD$

Checks and Money Orders MUST BE USD$
and Drawn on a US Bank or branch.

Add $5.00 for Air Mail Subscription to
Future Adventures Unlimited Catalogs

SPECIAL NOTES

RETAILERS: Standard Discounts Available

BACKORDERS: We Backorder all Out-of-
Stock Items Unless Otherwise Requested

PRO FORMA INVOICES: Available on Request

VIDEOS: NTSC Mode Only. Replacement only.

For PAL mode videos contact our other offices:

European Office:
Adventures Unlimited, PO Box 372,
Dronten, 8250 AJ, The Netherlands
South Pacific Office
Adventures Unlimited Pacifica
221 Symonds Street, Box 8199
Auckland, New Zealand

Please check: ☑					
☐ This is my first order	☐ I have ordered before			☐ This is a new address	
Name					
Address					
City					
State/Province			Postal Code		
Country					
Phone day		Evening			
Fax					
Item Code	Item Description		Price	Qty	Total

Please check: ☑	Subtotal ➡	
	Less Discount-10% for 3 or more items ➡	
☐ Postal-Surface	Balance ➡	
☐ Postal-Air Mail	Illinois Residents 6.25% Sales Tax ➡	
(Priority in USA)	Previous Credit ➡	
☐ UPS	Shipping ➡	
(Mainland USA only)	Total (check/MO in USD$ only)➡	

☐ Visa/MasterCard/Discover/Amex

Card Number

Expiration Date

10% Discount When You Order 3 or More Items!

Comments & Suggestions	Share Our Catalog with a Friend